ABANDONED
ILLINOIS

SECRETS BEHIND THE SPACES

LISA BEARD

AMERI~~
THROUGH
ADDING COLOR TO AM~

America Through Time is an imprint of Fonthill Media LLC
www.through-time.com
office@through-time.com

Published by Arcadia Publishing by arrangement with Fonthill Media LLC
For all general information, please contact Arcadia Publishing:
Telephone: 843-853-2070
Fax: 843-853-0044
E-mail: sales@arcadiapublishing.com
For customer service and orders:
Toll-Free 1-888-313-2665

www.arcadiapublishing.com

First published 2019

Copyright © Lisa Beard 2019

ISBN 978-1-63499-096-7

Typeset in Trade Gothic 10pt on 15pt
Printed and bound in England

CONTENTS

Acknowledgments **5**

Introduction **7**

1 Joliet Prison **9**

2 Goodman Manufacturing Company **20**

3 Savanna Army Depot **36**

4 Damen Silos **56**

5 The Huntley Grease Factory **71**

6 Various Abandoned Homes **81**

About the Author **109**

References **110**

ACKNOWLEDGMENTS

I am extremely grateful for the people who have helped me in one way or another with the culmination of writing this book, whether they have helped me in small or large ways, knowingly or unknowingly.

Thank you to my exploring buddies. I don't explore places with many people, but the people who have gone with me or helped me have added up, and without them, many of the places I have been able to explore wouldn't have been accessible or as fun. Thank you to Aubrey, Clara, Caleb M., Caleb R., Olivia, Sam, Lisa, Stacy, Nancy, Dave, Jessi, Peggy and Kevin, Carolyn, Connor, Nathan, Matt, Kurt, Alberto, and Emile.

Thank you to Chehalis and Arthur for their support in many ways, from idea bouncing to giving me a place to retreat in order to work and just "be."

Also, thank you to my co-workers and to my friends for being excited for me and patient with me, to Michael and to Dave for helping me with some decision-making, and to Steve for helping to allow me to make the time to shoot and write.

And last, thank you to Max and Quincey, my little crazy co-explorers and the loves of my life.

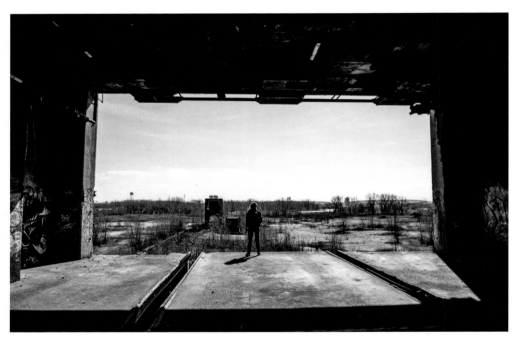

Overlooking ACME Steel and Coke in Chicago, IL [*photo by Nathan Johnson*]

INTRODUCTION

S ome people call this part of my life an odd obsession. But is it really that strange to want to document history through exploration of what's still standing in order to gain an understanding of what once was? In my opinion, there is much wisdom to be gained through the study of the past, and what better way to enlighten oneself and others about cultures, social problems, and humanity in general than by going to the actual places, researching and photographing them, standing in them, and touching them and the things in them? All things considered, "old" here in America is not the same as "old" in such a place as Italy or Spain. I honestly can't think of a better or more fascinating way to learn, and it's important to do it before these places are gone forever. In fact, some of the places in this book ARE gone now.

This "obsession" for me began at an early age, pretty much being given free rein to explore my surroundings while young. I would end up in abandoned homes, the woods, on gravel backroads, and inside all sorts of places. I let my imagination go wild, attempting to create my own worlds in these beautifully vacant areas that were sacred to me. I dreamed of building extravagant forts and sometimes did, made my own trails, and tried inventing things from robots to gem and fossil finders, and new ways to cook and create. I would constantly dig for buried treasures, hoping to figure out what was in these places before me, and I *made* things in these places: I painted rocks using different types of berries and bug guts, cut the grass with scissors and made designs, and once even had my own "pet," a lost dog that I took care of until I figured out what to really do with her. All of this was fine because I just needed to be home for dinner and bed. During the hot summers of northern Illinois, I was filthy but happy and in my element. It was a great secret I had for myself and sometimes, a few friends or my sisters.

Back then life was a lot like a *Choose Your Own Adventure* book crossed together with fantasy worlds from Tim Burton movies and *Pee Wee's Playhouse*, so looking back now, it's not really surprising that creating art narratives and stories with a strong focus on abandoned spaces and the surreal has become a driving force inside of me, and it's also not surprising that documenting forgotten places through writing and photography is also a passion. People ask me how I end up in these places, how I find them, and it's pretty simple. I just re-opened my eyes and my heart.

Becoming re-obsessed was easy. After years of stifling this part of myself, I came upon a place that restarted my passion. Explaining how I found it is difficult, as I felt drawn to it somehow, and it is in the middle of the woods in a very unlikely place. However, what I found was a history nobody else had happened upon or noticed. Conveniently, I had also started making pictures again, and so I had my camera. This is where it all started up again and in a more directed way. The first abandoned property I found is still my favorite of all and is still standing, untouched.

Yes, there are risks that come along with documenting these spaces. I have learned to be careful and prepared. I have learned a lot about being smarter about exploring, not being as impulsive. I don't actually break into places. I don't alter things, either; I like documenting places as I find them. There are still risks, but for me, in order to learn, they have been calculated risks worth taking.

I'm excited to share the adventures I've had and discoveries I've made with you in this work, Volume 1 of *Abandoned Illinois: Secrets Behind the Spaces*, and in future volumes.

1

JOLIET PRISON

"O ld" Joliet Prison is located in Joliet, IL. Joliet is approximately an hour south of Chicago and saddles historic Route 66, a well-traveled path for tourists and travelers. The prison itself, closed since 2002, encompasses more than twenty acres, and is surrounded by 25-foot-high limestone walls and razor wire. Made up of twenty-four buildings, Joliet Prison was comprised of cell blocks, guard towers, administration buildings, a hospital, a laundry facility, chapel, gymnasium, and cafeteria. Opened in 1858, Joliet Prison was built to replace the Illinois State Prison in Alton, IL, and by the late 1800s, housed nearly 1,300 inmates and employed over 500 workers (Sullivan, 2016).

Overcrowded and crumbling since the 1920s, Joliet Prison became one of the nation's largest prisons. According to David Heinemann, reporter for *The Chicago Tribune*, "It employed wardens who launched innovative reforms to the penal system, as well as some of the harshest disciplinarians to ever run a prison" (2002).

When built, Joliet Prison was created using the "penitentiary" concept developed by the Pennsylvania Quakers in the 1790s. The Quakers believed it was important that the structure of a prison should be "formidable, as to create fear in the hearts and minds of those who entered and also to put fear into the hearts of those who were contemplating a criminal act" (Lawson, n.d.). Because this form of imprisonment was meant to be not only physically imprisoning but mentally too, certain features of prisons from this Doric-style architectural model, or a more ornate style of gothic architecture, are present: overbuilt campuses to house even the most dangerous of criminals, window bars of extreme thickness, massive cornices with narrow slits for windows, solid stone construction, castellated walls and towers with turrets, and low and domineering buildings.

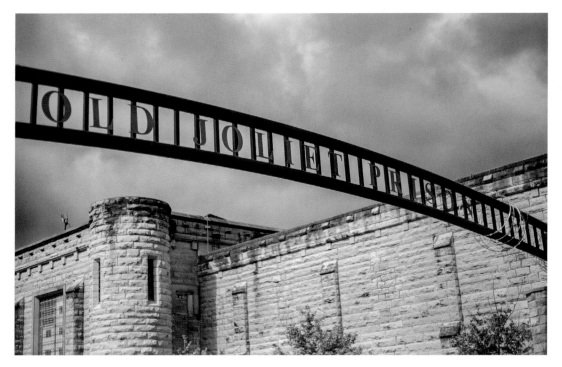

The official entrance into Old Joliet Prison

Razor wire surrounds the perimeter

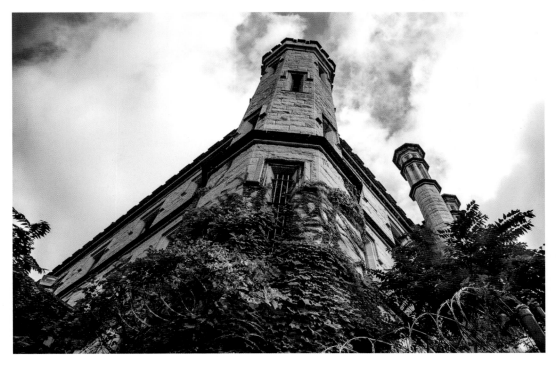

Intentionally intimidating architecture

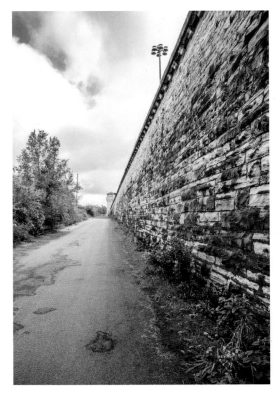

The outer walls of the prison

Wardens at Joliet did not shy away from using harsh conditions and punishments for the inmates of this maximum-security prison. Some cells were 6 feet by 9 feet and held three men, conditions were silent most of the day, and punishments used included the shower bath, crucifix, yoke and buck, the widow, the sing-sing slide, the hole, the dark cell, the bull ring (which was flogging), and the hummingbird, which was use of an electric battery applied to one's spine (Lawson, n.d.).

Particularly interesting is the Administration Building, which also housed inmates, including a women's prison, on the top floor. Although filled with prison cells, this building contains especially ornate wrought-iron staircases, arched doorways, marble fireplaces, and rooms full of written records that were once near inmate areas.

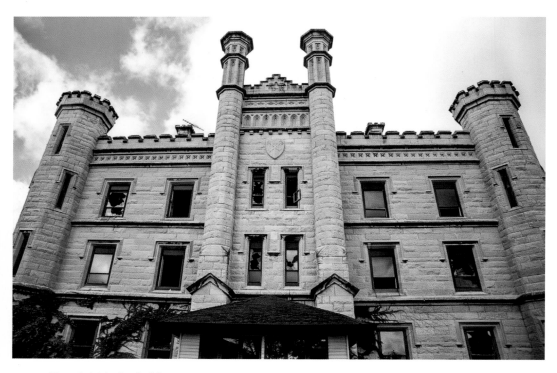

The administration building

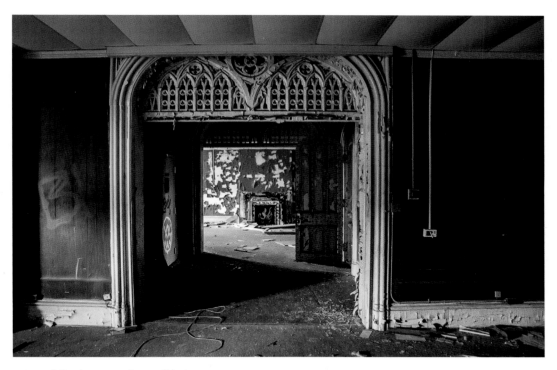

A fireplace opposite a cellblock

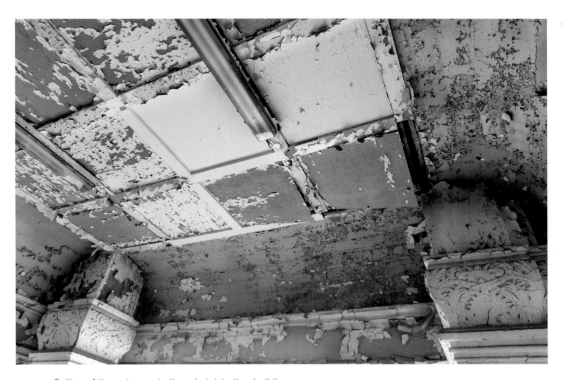

Ceiling of the entryway to the administration building

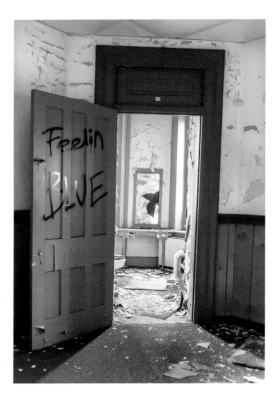

Bathroom in the administration building

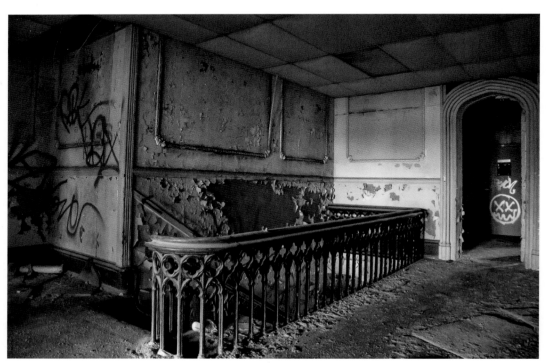

Ornate iron stairways lead to the second level of the administration building

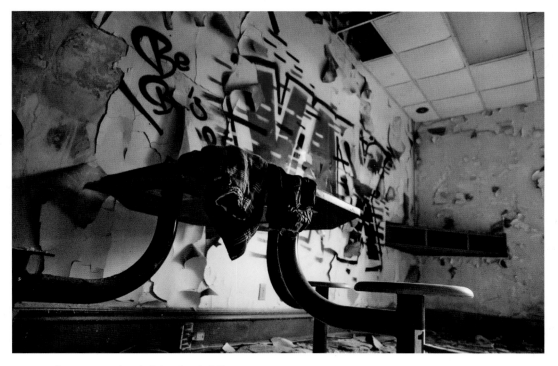

Common area in administration building

Joliet Prison is known for housing some famous inmates including POWs from the Civil War, Nathan Leopold, Richard Loeb, and John Wayne Gacy. The facility itself has been used as the backdrop for productions, most famously the film *The Blues Brothers* and Season One of the popular television series *Prison Break*.

In 1925, Stateville Correctional Center was built in Joliet, less than a mile away, and was meant to replace Joliet Prison; however, doors remained open until 2002 when it was closed due to budget cuts, overcrowding, and aging buildings unfit for housing prisoners. When closed, most staff and prisoners were transferred to Statesville, and Joliet Prison has been left to deteriorate. After being vandalized by trespassers, explored by those who are curious, and suffering accidental fires as well as arson, the prison will finally be used, starting in 2018, as a tourist attraction. Tours were scheduled to be offered in late summer by The Joliet Area Historical Museum. Also Evil Intentions, a haunted house operator from Chicago, will be using parts of the prison around Halloween (Okon, 2018). While the prison was once viewed as a shameful part of its past, the city of Joliet has now seemed to embrace this part of its history. "Going to Joliet" was once considered an ominous phrase when uttered, but now the prison has become intriguing to many, and the town even sports its own professional baseball franchise, The Joliet Slammers, a proud reference to its prison-rich history.

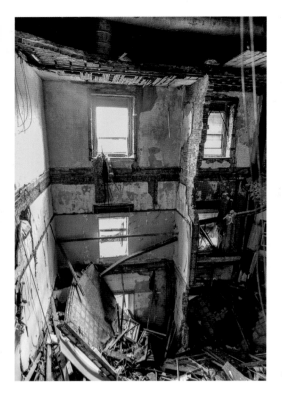

"The Pit"

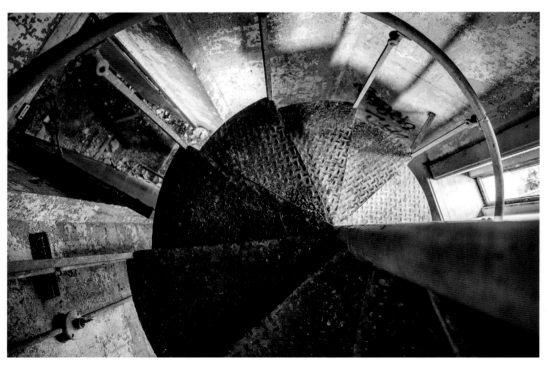

Skinny spiral passageway from top to bottom floor in the administration building

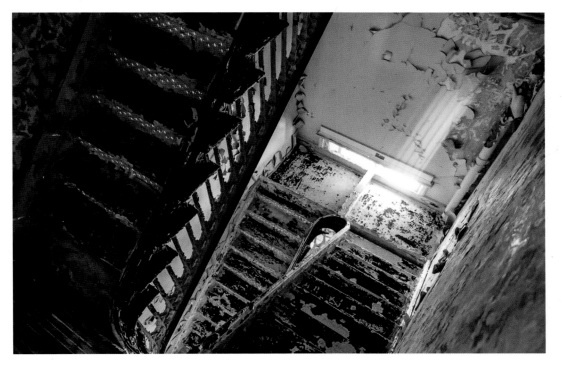

Cast-iron stairways

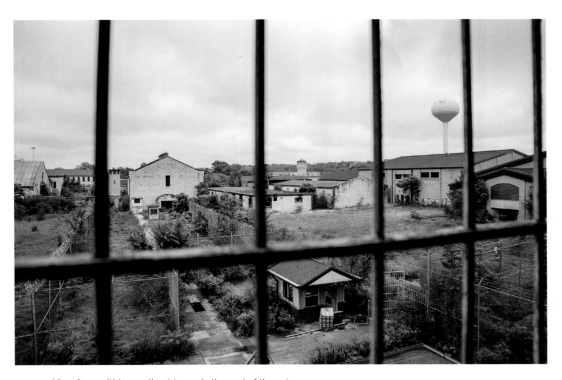

View from within a cell out towards the rest of the prison

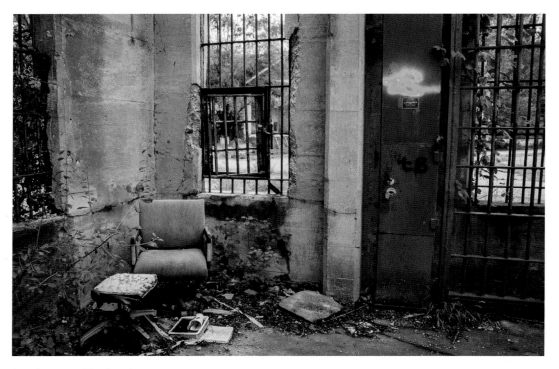

Guard area outside of a prison entrance

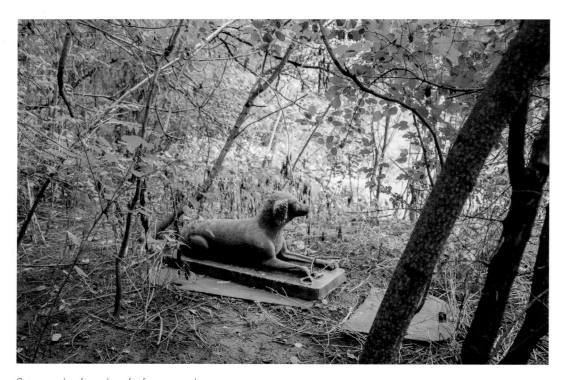

Grave marker for a dog of a former warden

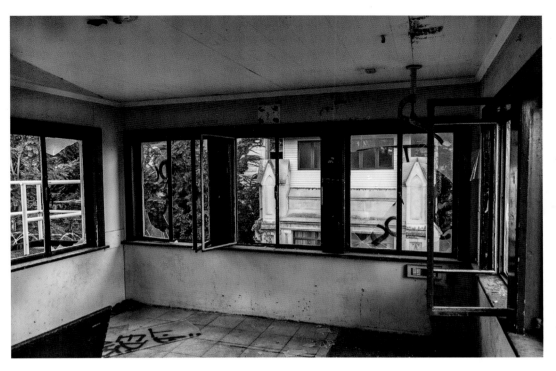

View from a guard tower

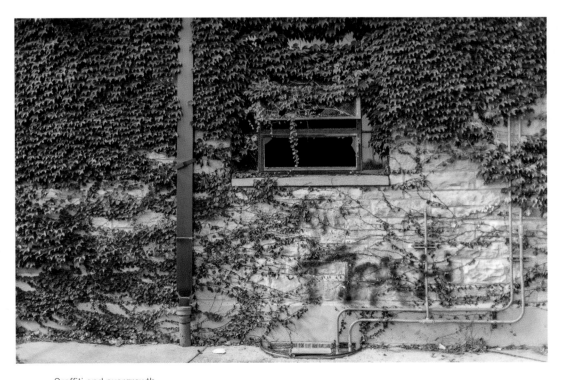

Graffiti and overgrowth

2

GOODMAN MANUFACTURING COMPANY

I n the Back-of-the-Yards neighborhood on the South Side of Chicago on seventeen acres of rocky, brush-spotted land is what remains of the original site for Goodman Manufacturing Company. Occupied in January of 1900, the way into the building is not exactly easy: one must climb an embankment up onto old railroad tracks, follow them through an active shipping yard and through large container storage facilities, slide down another embankment, and then wrestle through rubble and debris to get to the building and find a way inside.

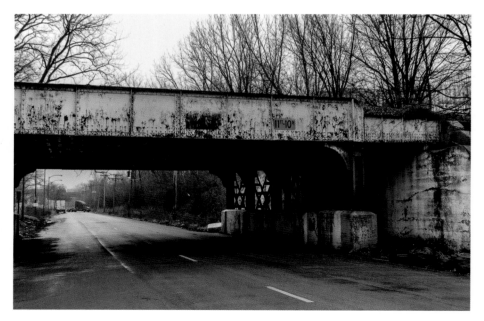

Route taken to find the Goodman building

Route taken to find the Goodman building

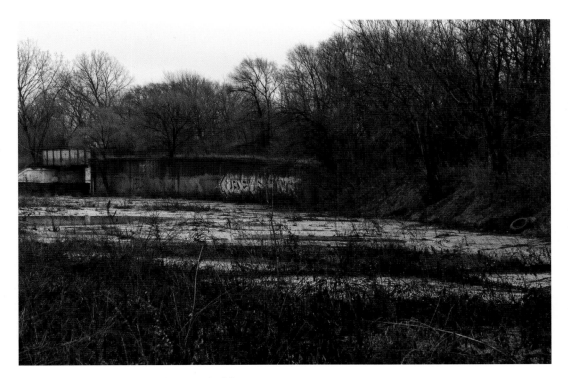

Route taken to find the Goodman building

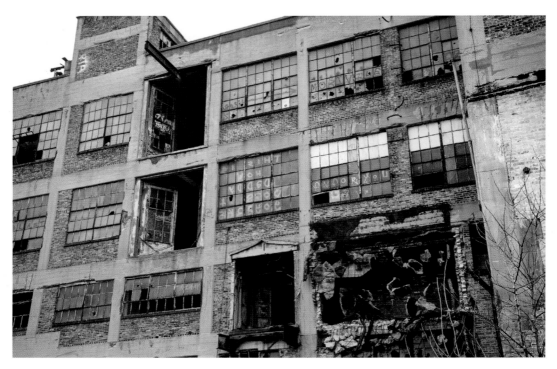

Outside view of Goodman Manufacturing

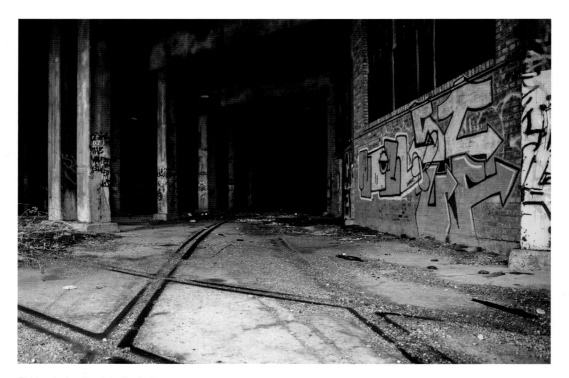

Old tracks leading into the factory

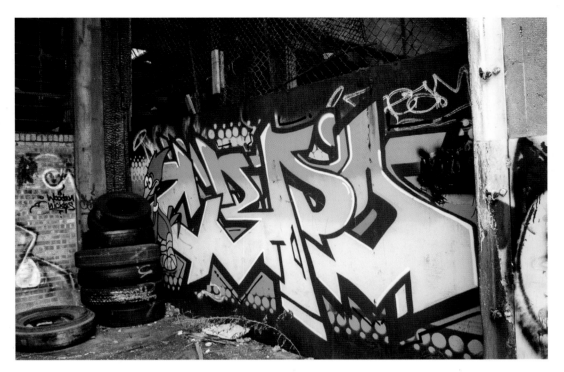

Outside of an entrance

Goodman Equipment Company, as it was known in 1900, was started by Herbert Goodman, who marketed mining locomotives invented by his brother-in-law, Elmer Ambrose Sperry, also inventor of the Sperry Gyroscope. Although Goodman died in 1917, this 650,000-square-foot factory was occupied by the company until 1989 when the company downsized to a 63,000-square-foot, 3.2-acre space in Bedford Park, IL (Wiedrich, 1990).

Locomotives built here were the first electric locomotives used for underground mining, and by 1904, Goodman locomotives were delivering freight via tunnels beneath the downtown city streets of Chicago to merchants (Wiedrich, 1990). By 1906, Goodman expanded internationally for the first time, and from then continued to expand. In the 1930s Goodman Equipment also began manufacturing diesel-powered locomotives for use in hard-rock mining in underground shafts with ventilation and scrubbing systems. Goodman also built personnel and material carriers to move men and materials inside of mines, built the first electric coal cutting machine, and beginning in 1979, also manufactured blow molding machinery used to make such products as toys, furniture, containers for liquids, and various automobile components. The locomotives built here ranged in weight from 1.5 tons to 50 tons (Wiedrich, 1990).

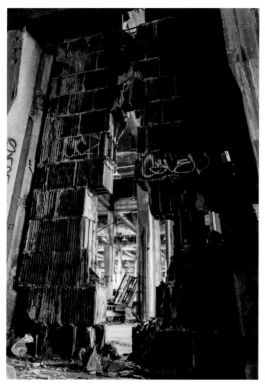

View into bottom level of the factory

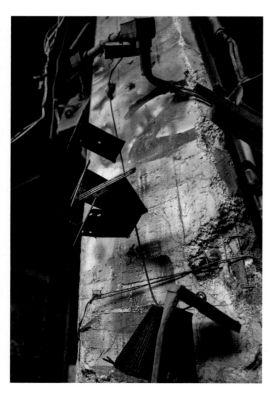

Old machinery on the bottom level of the factory

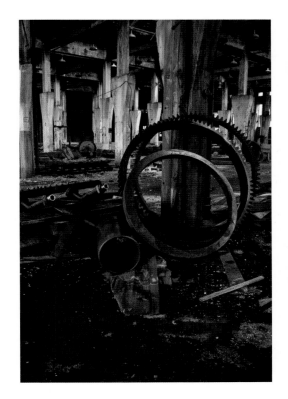

6-foot gears and large pipes are strewn around
the factory

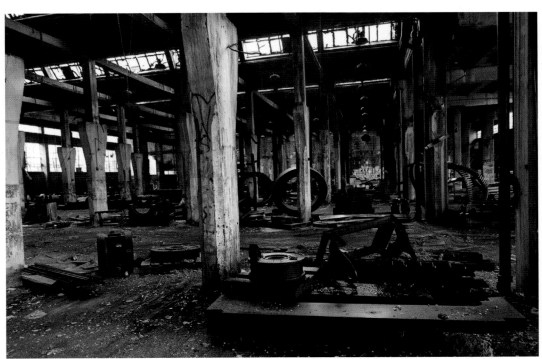

The bottom level of the factory

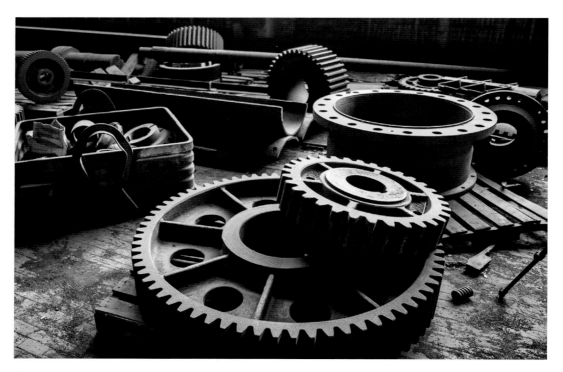

Heavy gears

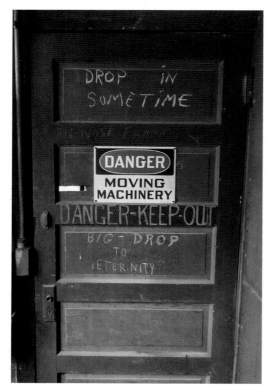

Explorer humor

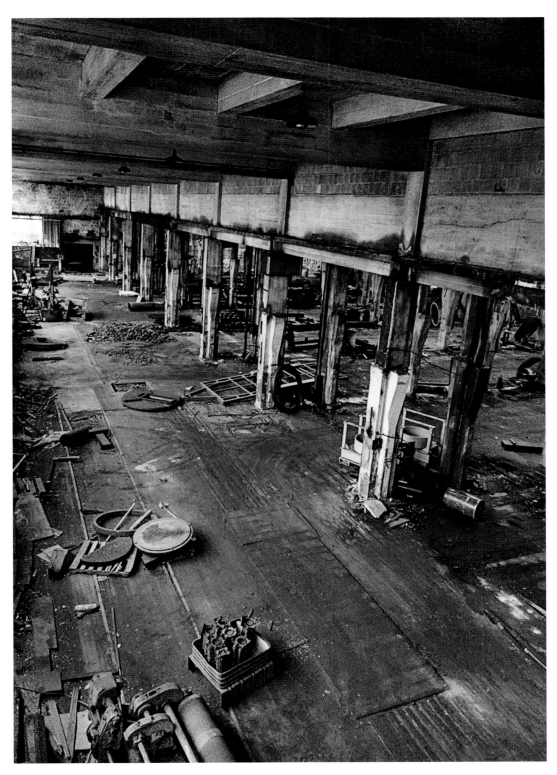

Behind the door

When this factory was vacated for the Bedford Park site, the building was used as a storage for parade floats used by the city of Chicago, which is why this factory is also known as The Parade Float Factory. Parts of the floats can still be found today, but the building itself is graffiti-filled, has many dangerous structural issues, and has been vacated completely since at least 2014.

Goodman Equipment Company completely ceased operating in May 2003 when it was bought out by Bateman Trident in South Africa, who acquired all global manufacturing and distribution rights to the company and by W.W. Williams, who acquired all parts and intellectual material needed to continue making products (National Mining Hall of Fame, 2018).

 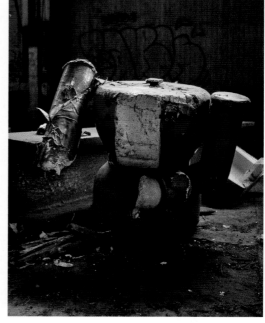

Parts of parade floats litter the factory

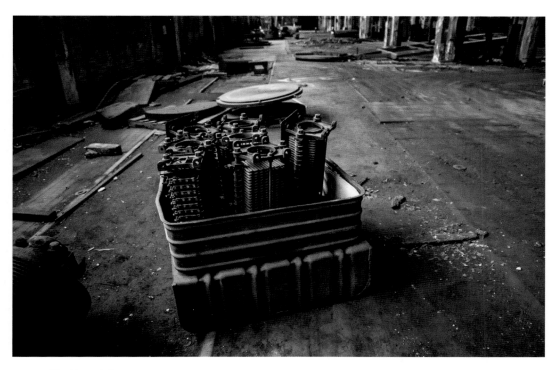

Machinery left over

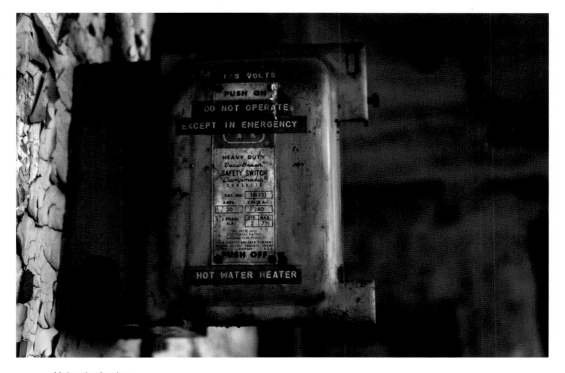

Hot water heater

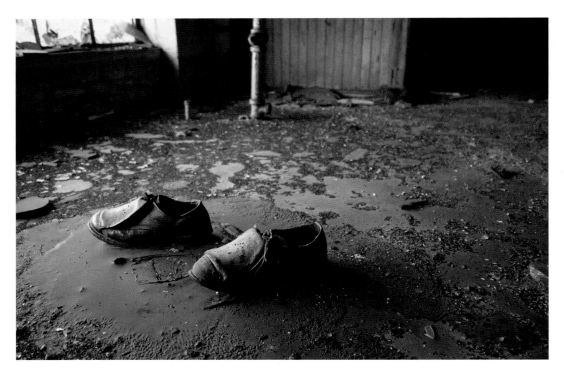

Steel-toe work shoes

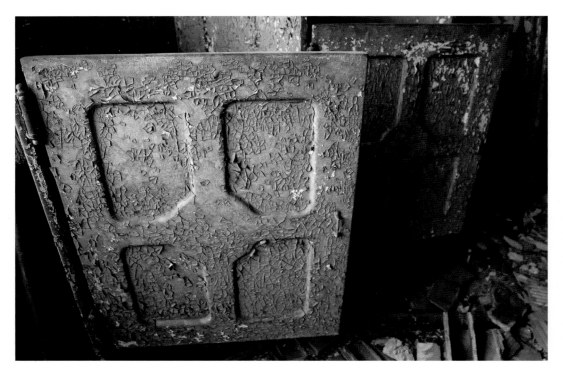

Old bathroom stalls

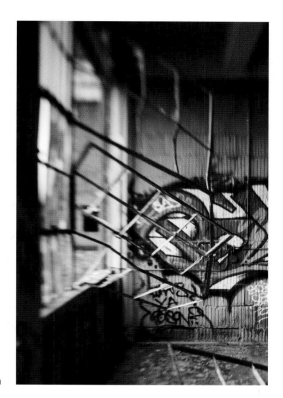

Remnants of an explosion

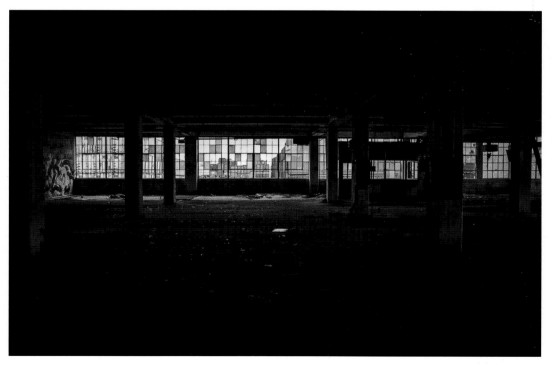

Fourth floor

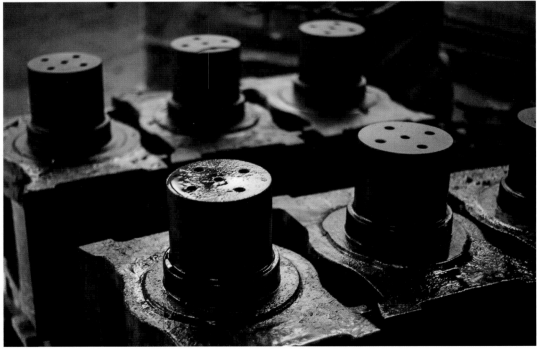

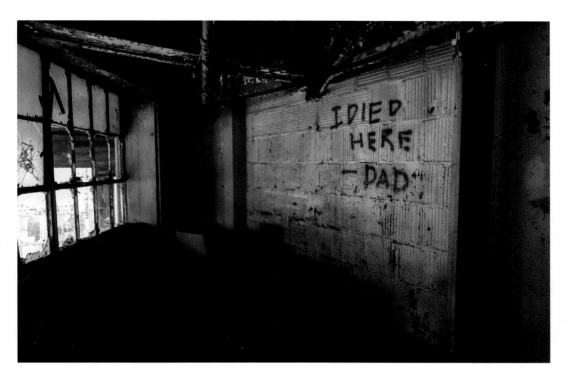

Breakroom

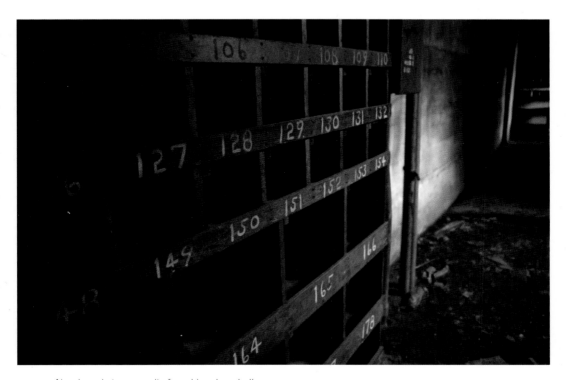

Numbered storage units found in a long hallway

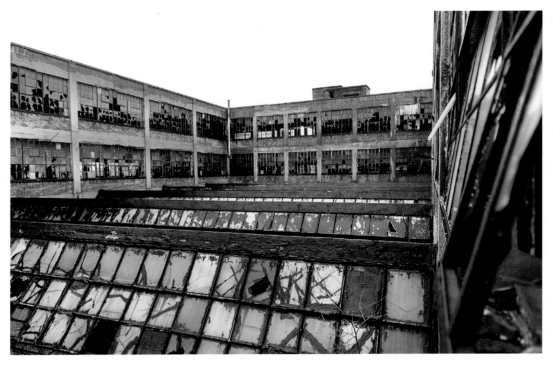

A beautiful, window-covered rooftop

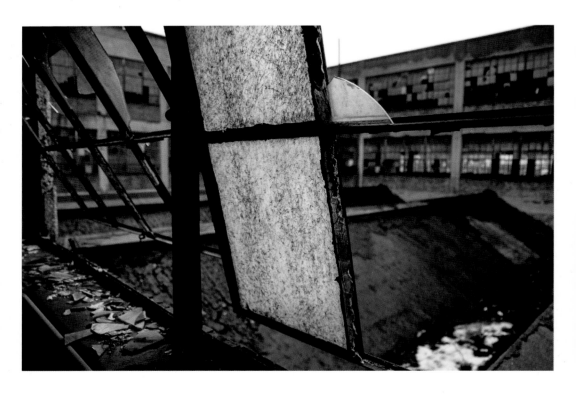

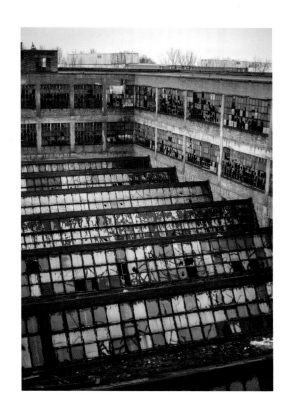

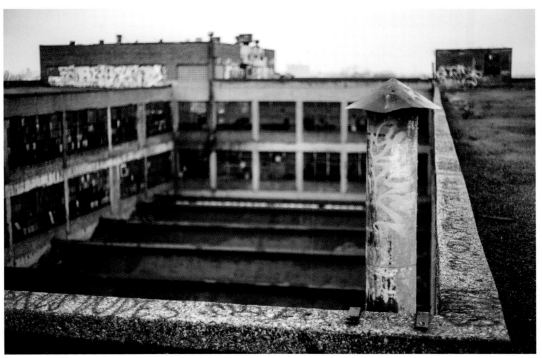

The rooftop

3

SAVANNA ARMY DEPOT

What is now known as the Savanna Army Depot was formed in 1918 by the U.S. Military in 1913 when they bought 13,000 acres on the edge of the Mississippi River in western Illinois near Savanna. Built on the longest natural dune system in the state of Illinois at 7.5 miles long and 70 feet above the Mississippi River, it contains the Lost Mound, a post-glacial hill. According to the U.S. Fish and Wildlife Department (2016), "The mound did not appear on early maps of the region; however, the 'lost mound' has since been found and is featured on recent topographical maps" (p.2).

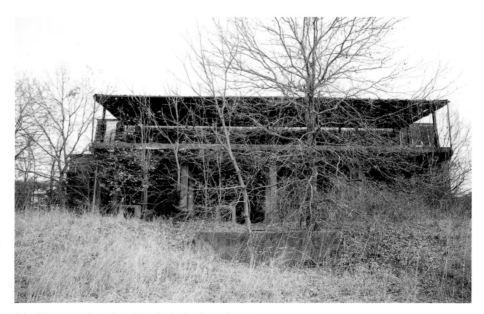

A building near the railroad tracks in the Army Depot

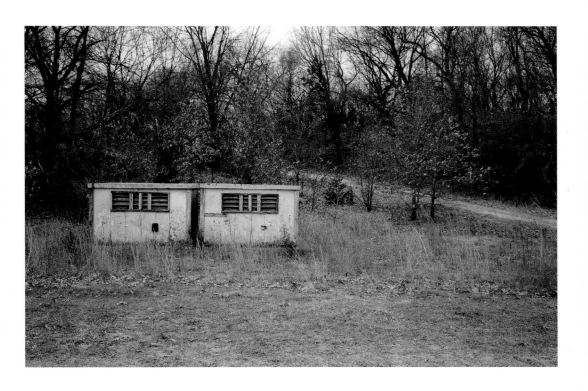

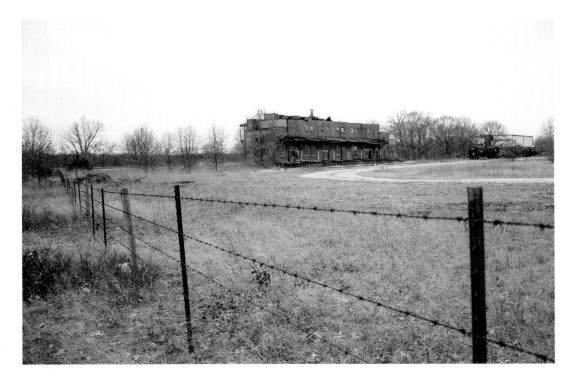

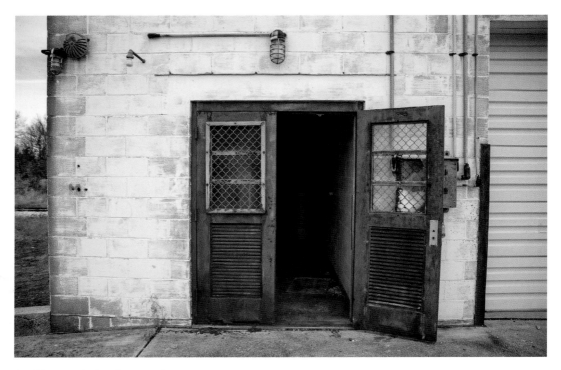

An old power plant on the grounds

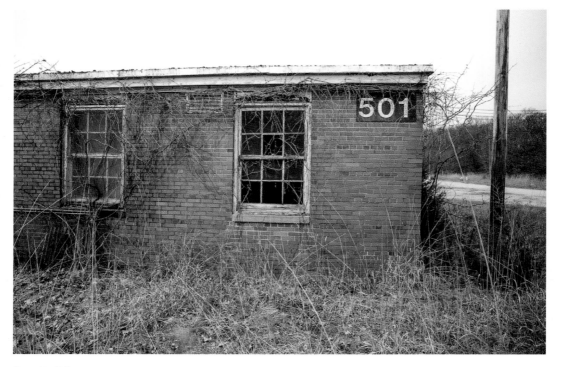

Guard buildings

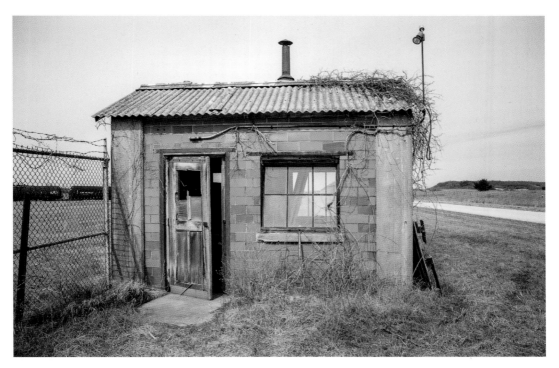

Guard buildings

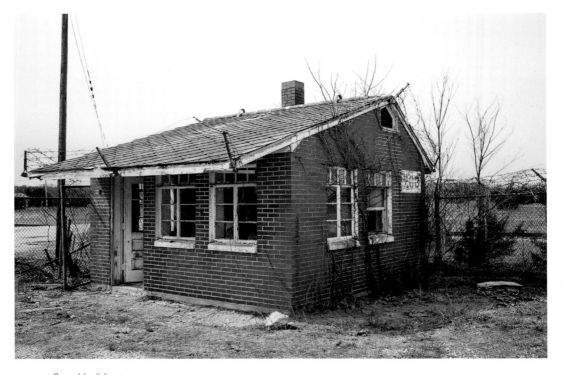

Guard buildings

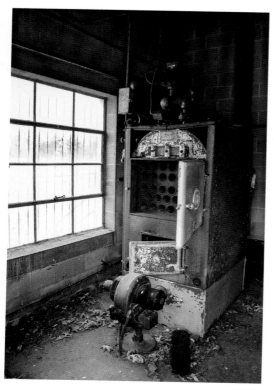

Generator

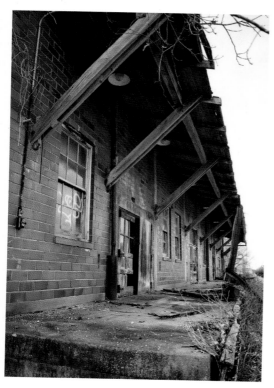

Small loading building

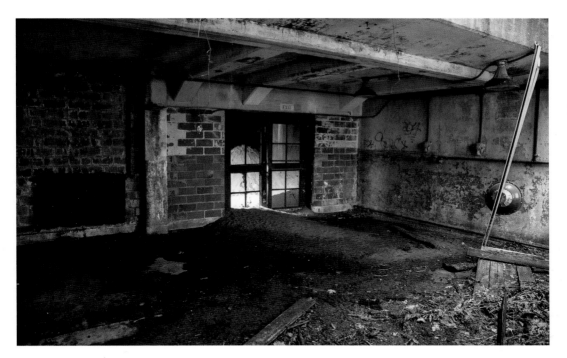
Inside of the loading building

When it was bought, it was called the Savanna Proving Grounds and was a sand prairie used to test artillery (Lost Mound Unit, 2016). First used to test 75 and 155mm howitzers, or artillery pieces characterized by short barrels, firing shells on high trajectories at low velocities in order to reach targets behind cover or in trenches, it was later expanded to store ammunition in warehouses after WWI. Barracks were also built for employees and munitions were built on site. "The Combined Shop" was built early on to store ammunition, engines, and vehicles. In 1921, the "Upper Field" was formed and stored forty-seven standard ammunition magazines or explosives, as well as thirty high-explosive magazines. It also contained a nitrate storage pit, which contained 260,000 tons of sodium nitrate for war reserves (Savanna Army Depot, 2018)

From 1921-1962, the depot was known as the Savanna Ordnance Depot. An "ordnance" is a branch of the Army that focuses on the supply and storage of weapons and ammunition. Eventually, between 1929-1940, 407 igloos were built to store "mustard gas," which is a "blister agent" designed to harm the skin, eyes, lungs, and gastrointestinal tract upon contact or breathing in of the gas. There is also 1,000-2,000 square feet of storage under the igloos, which are steel enforced with two-ton doors. Currently computers storing classified information are stored within these humps, but they have been covered with dirt and grass to hide them from aerial surveillance (U.S. Fish and Wildlife, 2016, p. 3).

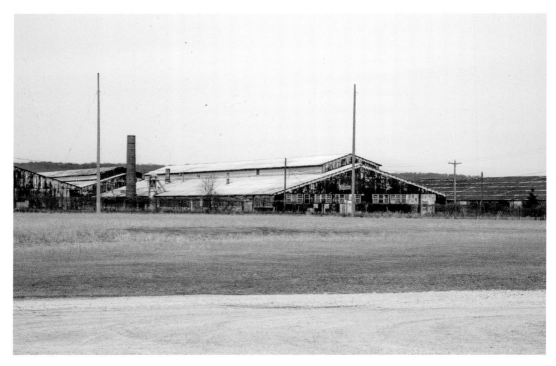

Large munition storage buildings

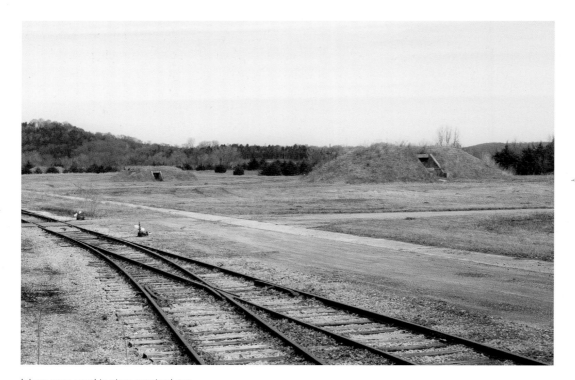

Igloos once used to store mustard gas

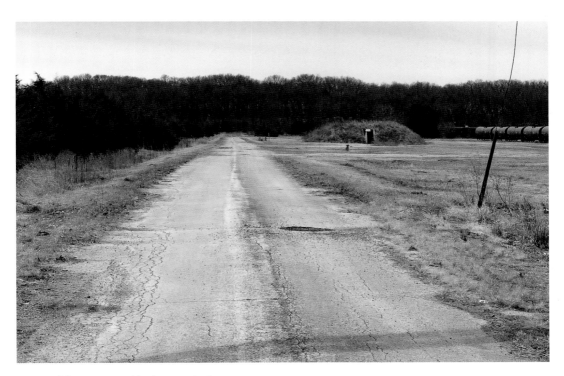

Igloos once used to store mustard gas

Additionally, between 1939-1942, four industrial plants were built on site—one building as a bomb loading plant, which loaded bombs with explosives during WWII. These bombs were used in General James Doolittle's famous raid on Tokyo in 1942 (Savanna Army Depot, 2018). Another plant was comprised of twenty-nine buildings that loaded ammunition with explosives. The third plant was an ammonium nitrate crystallization plant which was never used, but the last was a clipping, belting, and linking plant. This was a two-building plant used to package small arms ammunition (Savanna Army Depot, 2016).

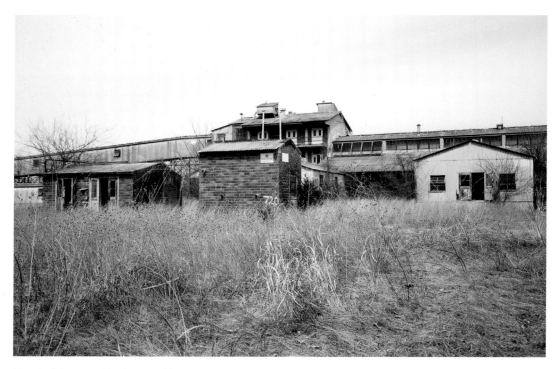

More buildings used to store munitions

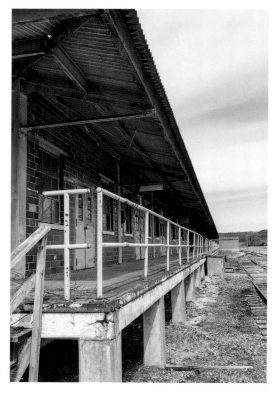

Long buildings on the tracks used as
ammunition-loading plants

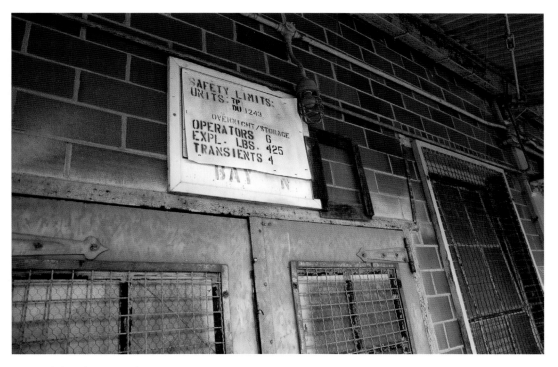

Safety signs everywhere

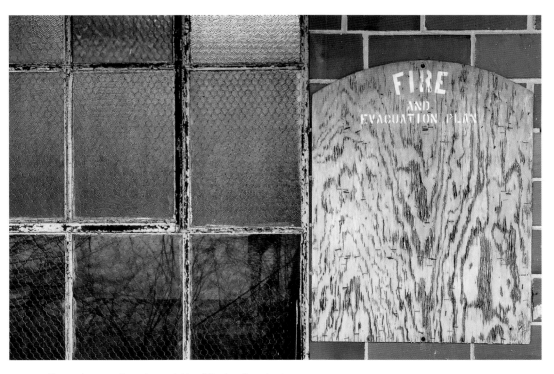

Fire and evacuation plan outside of the loading plant

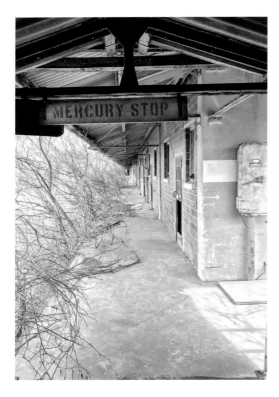

Mercury stop. As in explosive Mercury

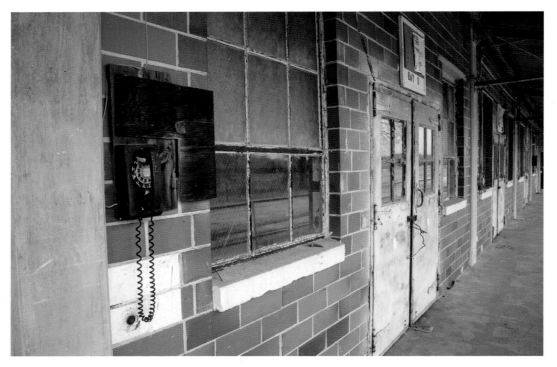

Emergency phone

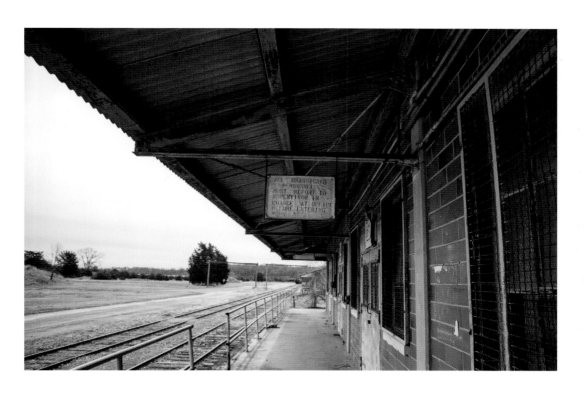

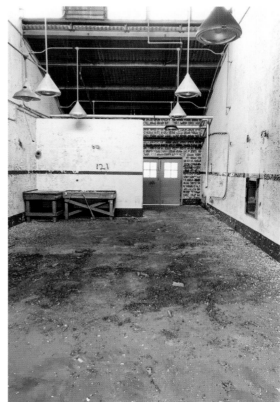

Inside of the loading facility

All loading rooms were exactly the same

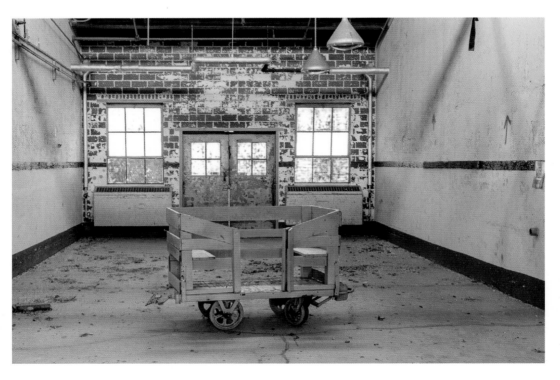

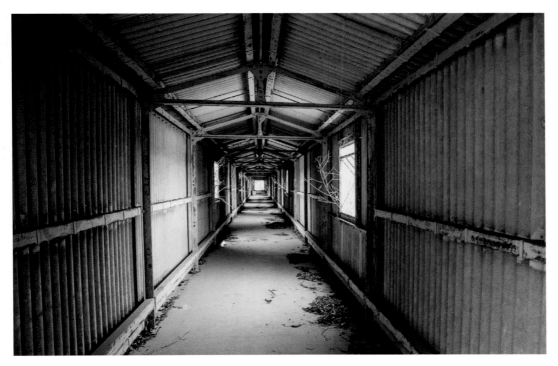

Aluminum tunnel leading to the Mercury Stop

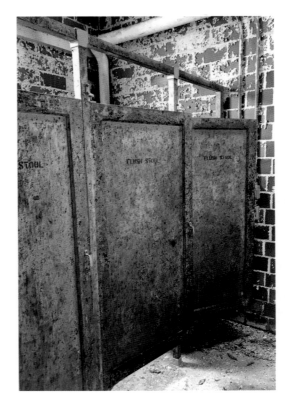

Loading plant restroom

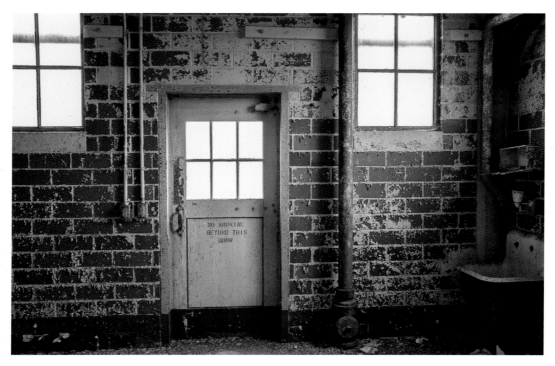

Loading plant restroom

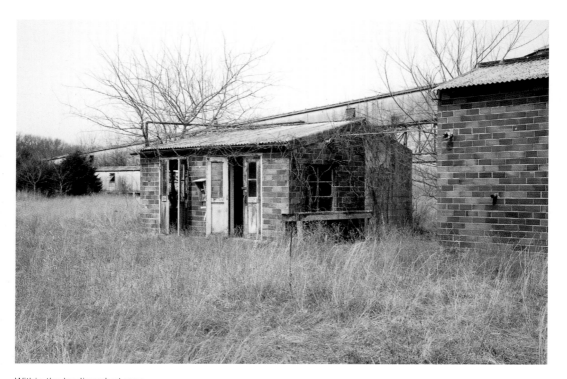

Within the loading plant area

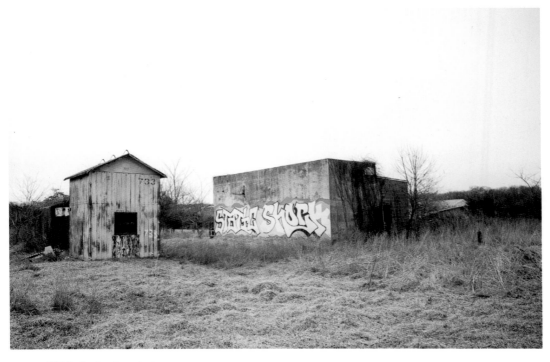

Within the loading plant area

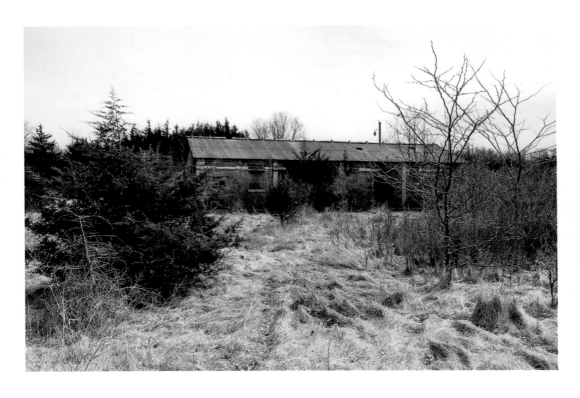

1941 saw the construction of a "Unit Training Center," or thirty-seven buildings used as quarters for 945 enlisted men and forty officers. Fifteen of these were temporary barracks. There were five mess halls, six recreation buildings, a guardhouse, and an administration building, among others. There was also a hospital built, made up of nine buildings. A fire/guard house was built, a diesel generating plant, and a field office (Source 4). By 1942, there were 7,195 employees at the Savanna Army Depot (Lost Mound Unit, 2016). Post WWII, the Ordnance Ammunition, Surveillance, and Maintenance School focused on technical, operational, and administrative training in all fields of ammunition and a Brass Reclamation Plant was built (1954) (Savanna Army Depot, 2016).

By 1962, the depot shifted to storage and recycling of old munitions and testing of new ones and was renamed the Savanna Army Depot. By 1995, only 500 people remained employed and the depot officially closed on March 18, 2000, as part of the Base Realignment and Closure Act. Over 13,000 acres were transferred to the U.S. Department of Defense, and in 2003, over 9,400 acres were transferred to the Illinois Department of Natural Resources as a part of the Lost Mound Unit of the Upper Mississippi River National Wildlife and Fish Refuge. Only a little over 3,000 acres were actually transferred due to environmental contaminants needing cleaning. The remaining average will be transferred as the site is cleaned up in the future. Also, because unexploded ordnance remains on site, a large part of the area remains closed to the public. Only non-ground disturbing activities can occur on much of the future refuge land (U.S. Fish and Wildlife, 2016).

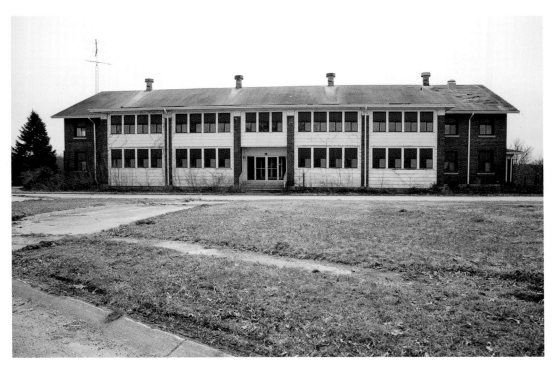

Part of the Unit Training Center complex

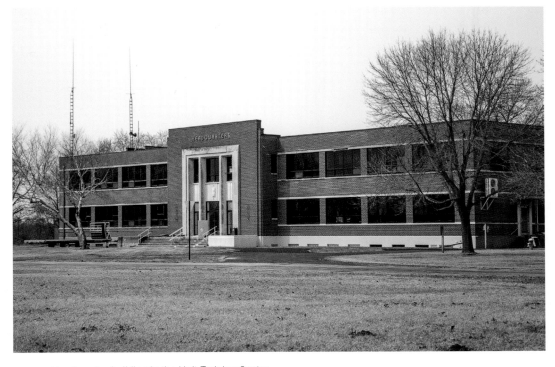

Headquarter building in the Unit Training Center

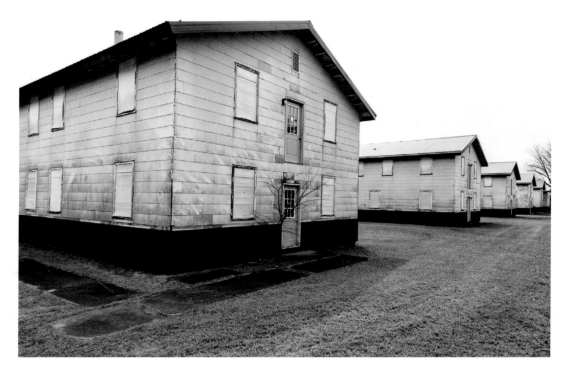

Barracks

No smoking

Overgrowth

4

THE DAMEN SILOS

I n 1832, void of skyscrapers, the tallest structures in the city of Chicago were 30-feet-tall grain silos. Conveniently standing at the intersection of the Illinois-Michigan Canal and the Santa Fe Railway, the Damen Silos stood out in the city's skyline. Although these often-rebuilt silos are not the tallest structures in the city by far today, they still stand out, and one can easily picture them as they once were.

Right: The Damen Silos

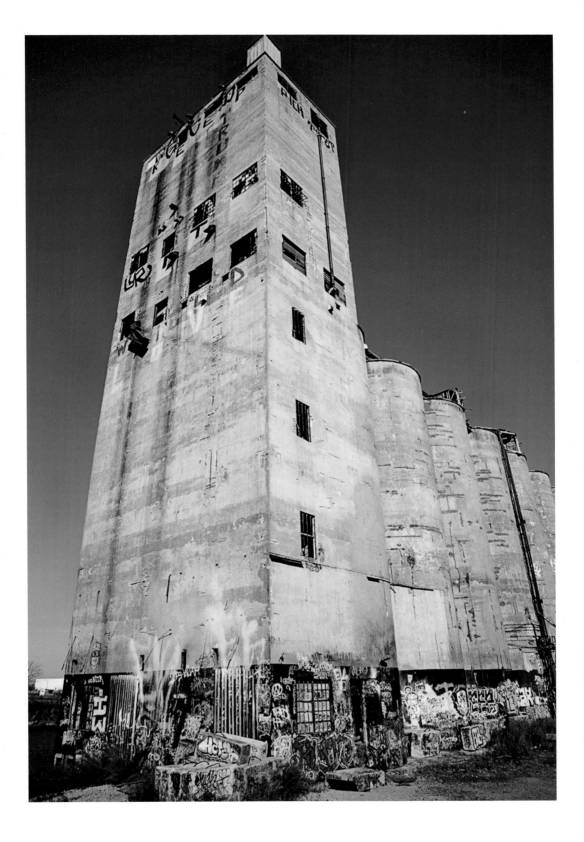

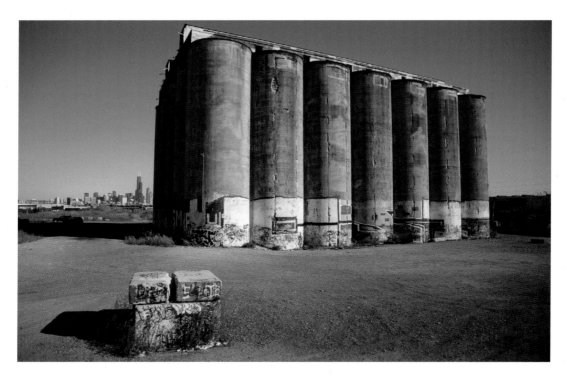

The Damen Silos looking north towards Chicago

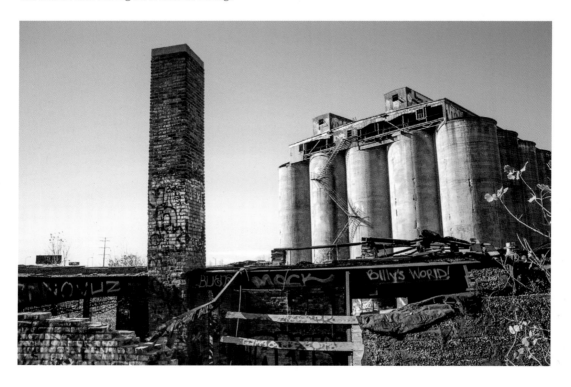

Unfortunately, grain silos, especially those not made of concrete, easily catch fire, and the Damen Silos are no exception; they have burned five times, four accidentally, since they first caught fire in 1832. After rebuilt silos burned completely down again in 1905, and some workers on the scene died, John Metcalf, a civil engineer, was hired by the Topeka and Santa Fe Railroad to design new silos and a system that would hopefully head off future instances of fire. By the time they were rebuilt in 1908, there were thirty-five concrete bins that had a 1-million-bushel holding capacity. The structure included vents and windows, a 1,500-horsepower power plant, an elevator, driers, bleachers, oat clippers, and boilers, and a working house that was 225 feet long and 56 feet wide. Each bin had a 23-foot inside diameter and stood 80 feet tall (Ketchum, 1907).

Although it was thought that this design would prevent future fires from occurring, there is not much that can be done when grain dust mixes with oxygen: it creates a volatile gas that will explode when exposed to high temperatures, and another spontaneous explosion occurred in 1932. Again, the silos were rebuilt, but this time to hold double the capacity of bushels (Ketchum, 1907).

In 1977, a final explosion occurred. This time, due to a gradual shift in the needs of society, the silos would not be rebuilt. They were shut down this time, and were not used again until 2002, when film director Michael Bay transformed the silos into what looked like China for a backdrop for *Transformers 4*, starring Mark Wahlberg. For this film, there was a purposeful explosion and the silos were blown up a fifth time using a mixture of CGI and dynamite, leaving the disconnected and dangerous passageways and rubble. Today, some of the fifteen-floor grain silos remain, full of graffiti. Tunnels also remain and stretch under at least half of the twenty-four-acre parcel of land. Although very dangerous, urban explorers and photographers enjoy the challenge of trying to make it to the top of these 113-year-old structures. (Kumer, 2018).

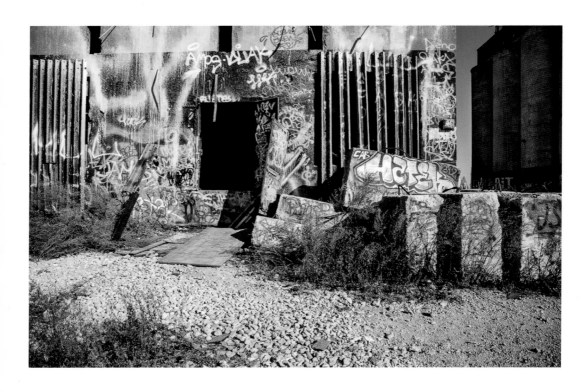

Graffiti covers the silos themselves and what
is left inside

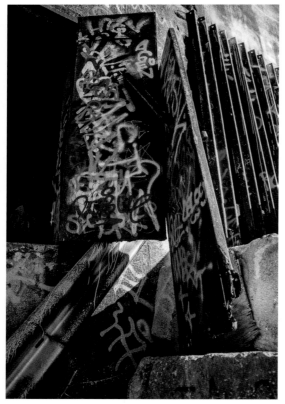

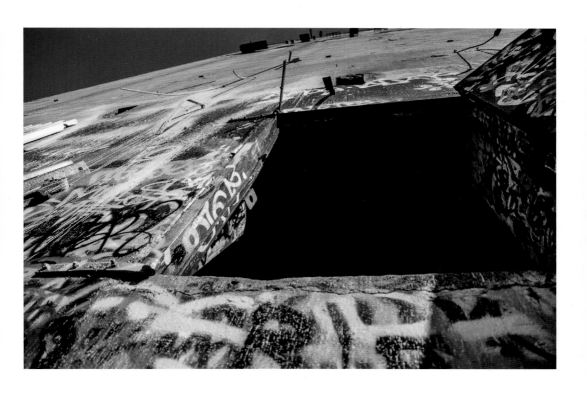

View to the top from ground level

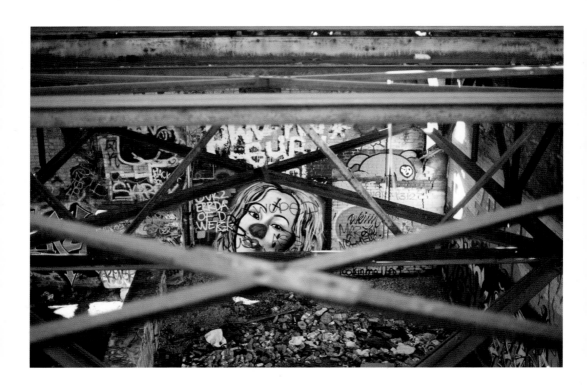

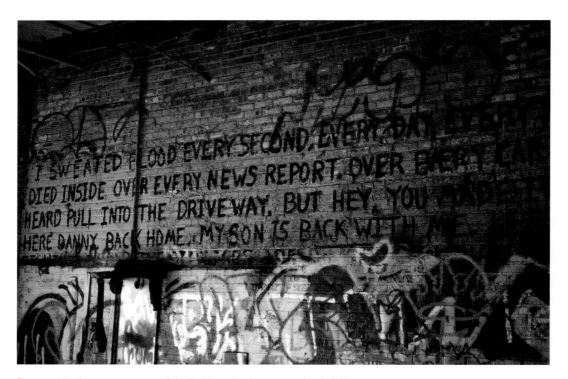

Poetry and writing covers many of the inside walls of the remaining buildings

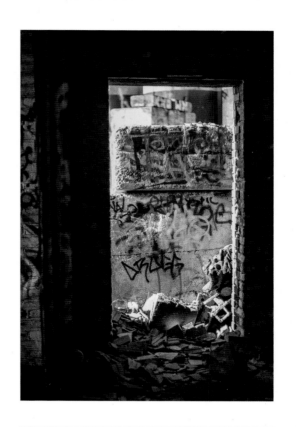

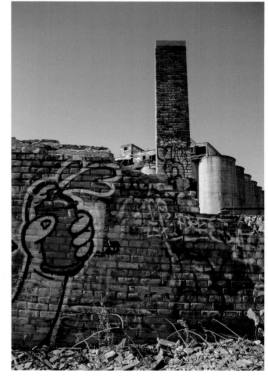

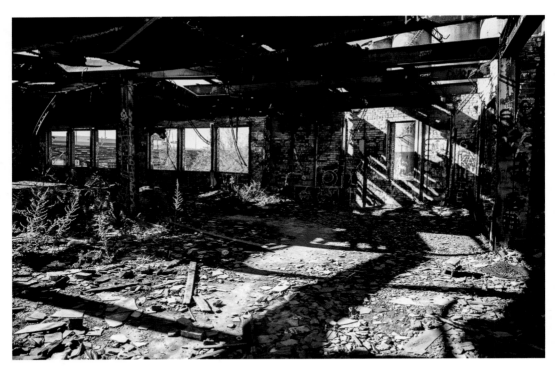

Inside one of the outbuildings

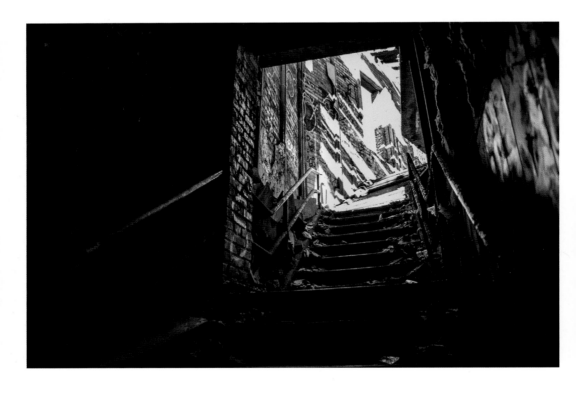

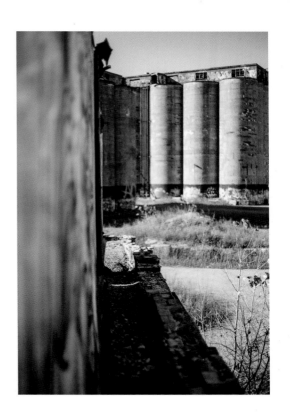

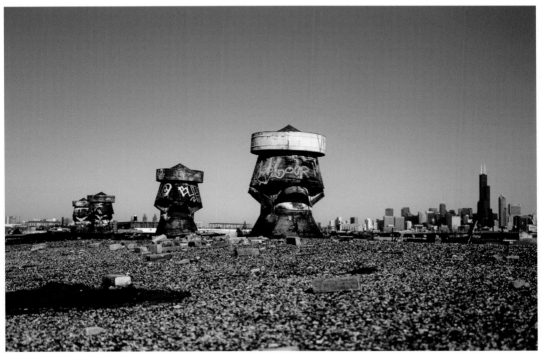

View from the top of an outbuilding

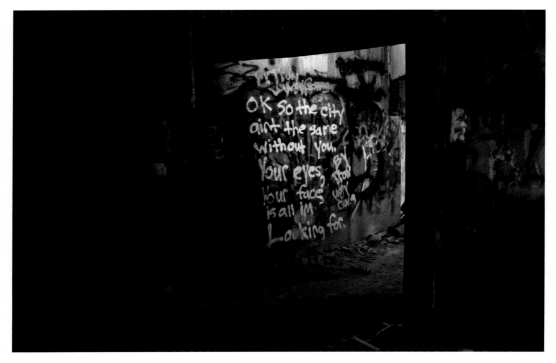

Graffiti poetry leading into the tunnels below the silos

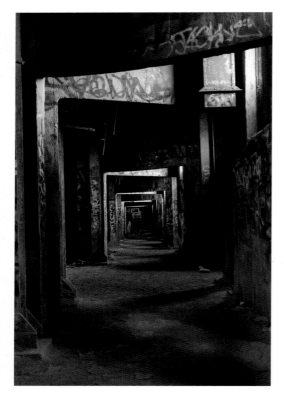

One of the tunnels below the silos

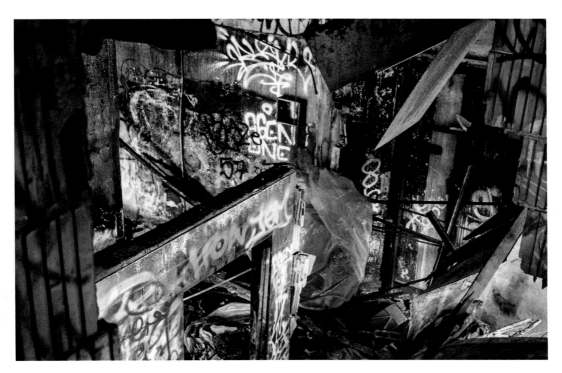

Starting one climb up

View from the inner walls of the silos

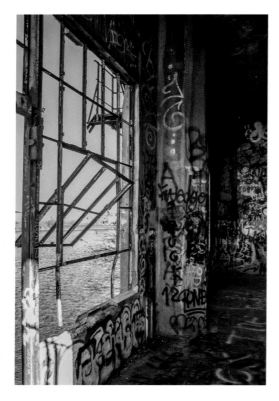

Leading to another way to the top, overlooking the South Branch of the Chicago River

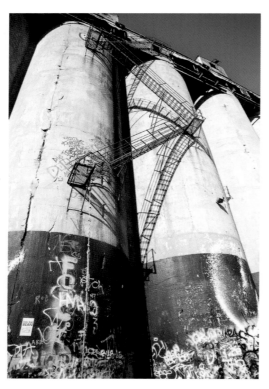

Rope leading to the corroding stairs up to the top

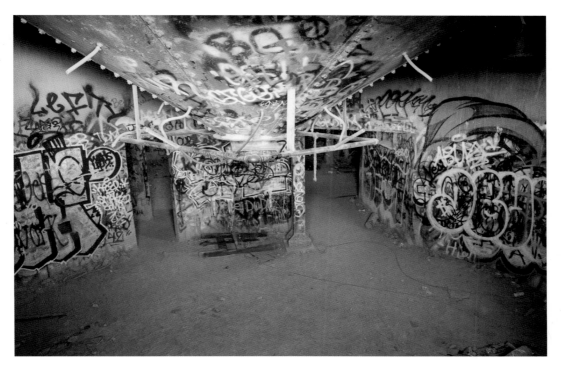

The bottom of one bin; a funnel

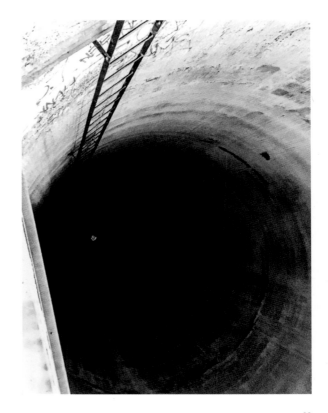

View down into the bin

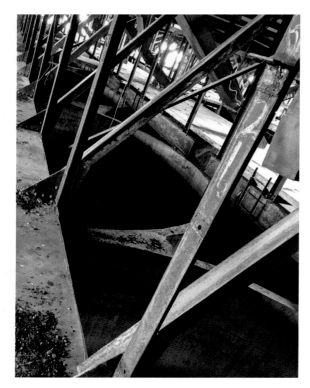

The top of the silos

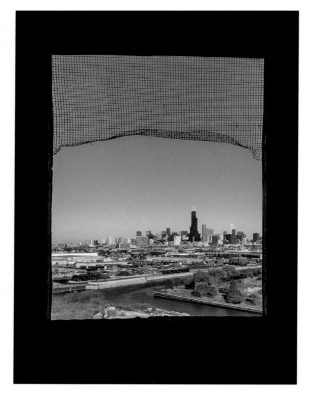

City view from the top of the silos

5

THE HUNTLEY GREASE FACTORY

After parking, hopping onto some train tracks, walking almost a mile into what seems like the middle of nowhere, spotting an old bridge, climbing down the embankment, finding the opening in some thick woods, following a thin trail that goes deep within, and jumping over a shallow creek, one can finally explore the ruins of what is now lovingly referred to as "The Grease Factory." Made up of a few large cinderblock buildings, The Grease Factory has been an interesting part of McHenry County history for over seventy years. Many ominous rumors circulate about what the factory was—more specifically, about what it was used for.

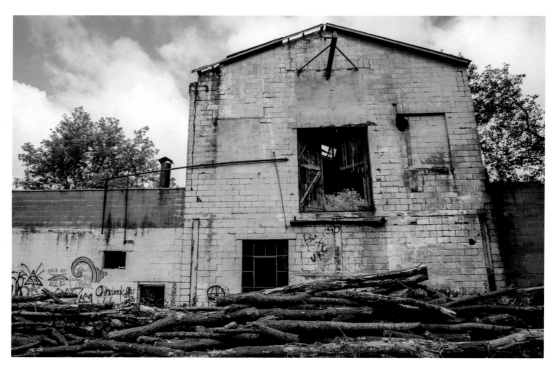

The Grease Factory

The way to the factory

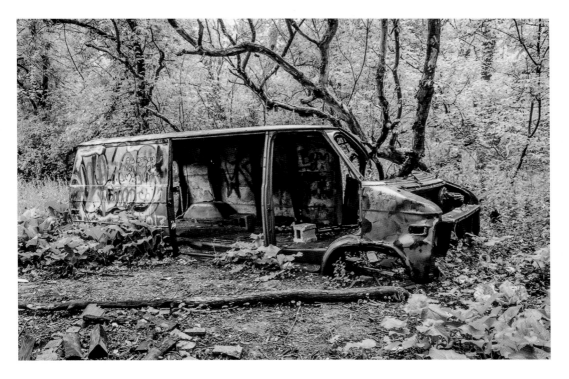

Junked vans, cars, and trucks lead to the old factory

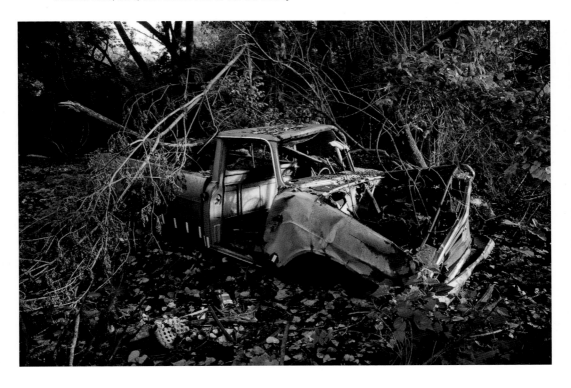

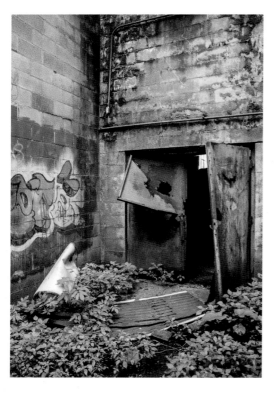

One entrance into the factory

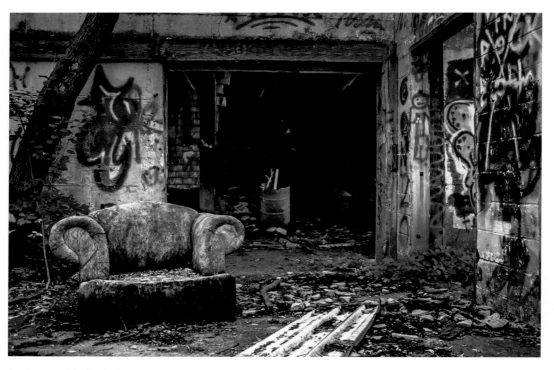

Another way into the factory

The truth is that The Grease Factory was indeed a grease factory for most of its existence. In 1947, the factory was known as D. K. Products Company. This factory itself was a rendering plant which would explain the overwhelmingly putrid smell people remember coming from it while it was in use. The function of a rendering plant is to convert kitchen grease, livestock carcasses either from slaughterhouses or farms, and other waste into industrial fats and oils so it can be used for products like feed, soap, or a variety of other things. It has been remembered that D. K. Products did keep horses on site in a pasture nearby and slaughtered them for meat, which was used for dog food (Marino, 2011).

In 1952, coincidentally (or not so coincidentally, as some rumors have it) there was a controversial meat scandal in the Chicagoland area where some Chicago meat producers were found to be using horse meat in their "100 percent beef" products, and around this time, D. K. Products halted their practice of slaughtering horses for meat and became a grease refinery.

In 1963, the building was sold to the owner, who opened the Fox Valley Grease Company, which originated in Elgin. The factory became fully operational in June 1971 and contained a large factory building, a large pole barn, and two trailers. There was also a boiler repair company on site (Marino, 2011).

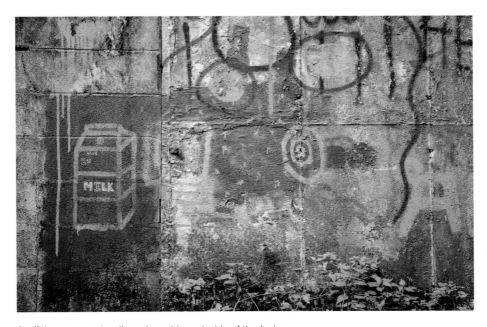

Graffiti covers most walls and machinery inside of the factory

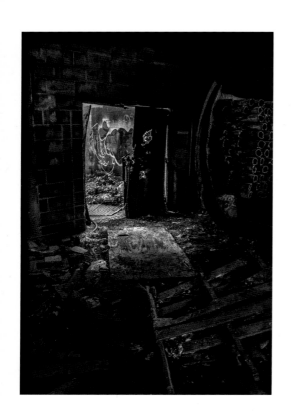

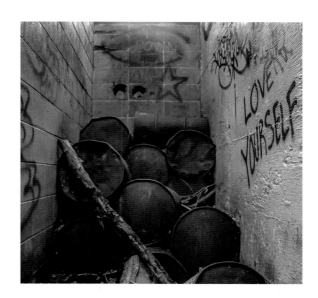

Right: Love yourself

Below: Rusted machines and storage drums

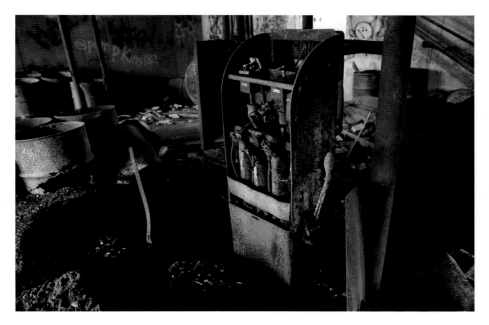

 After a 1979 fire, thought to be an arson, wrecked a large part of the grease storage room, the property was never rebuilt for use as it once was. It was officially closed in 1982, and the company moved to a new site out of town. Currently part of the property is used for a towing business, but the cinderblock factory is largely grown over, has become a playground for graffiti artists and explorers, and large, heavy pieces of machinery remain along with random articles of clothing, junked cars and trucks, and remnants of what once was.

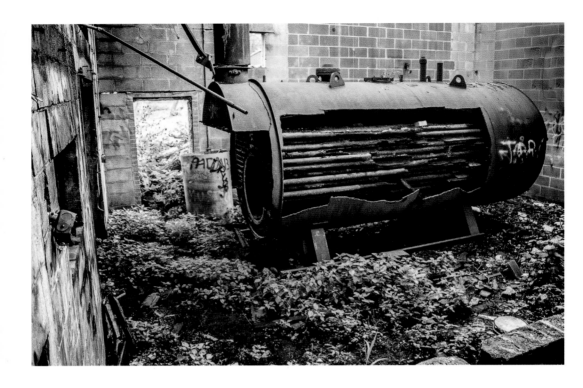

Rusted machines and storage drums

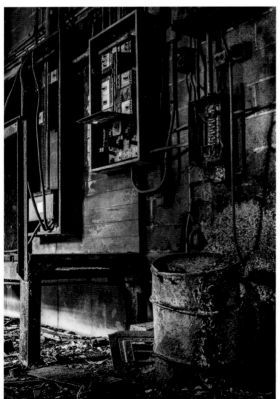

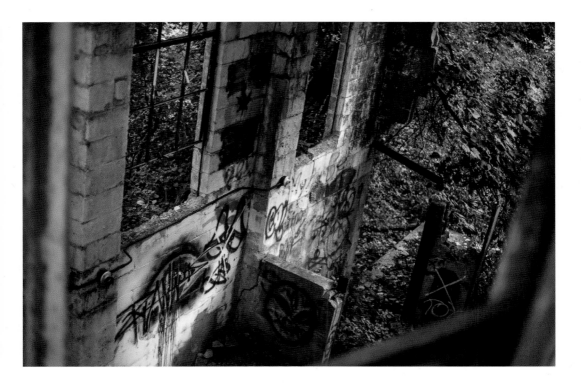

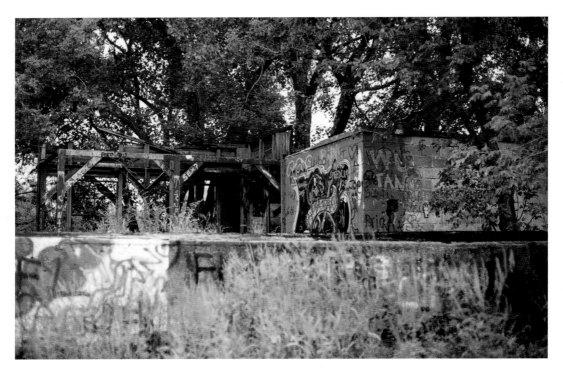

Ceiling level

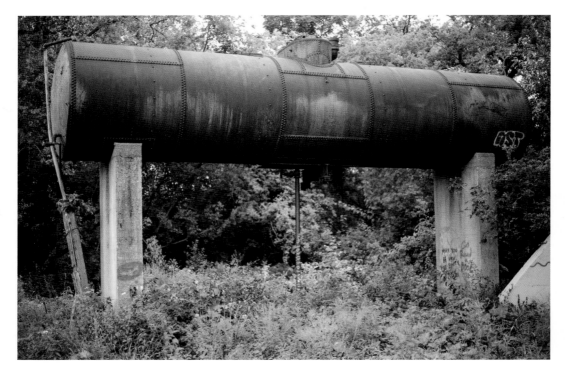

Large storage drum outside near the old pasture

6

VARIOUS ABANDONED HOMES

Although much harder to research than historical buildings, schools, or businesses, some of the most interesting stories can be found through abandoned homes.

It's fascinating what can be learned about a place and a time through what is left behind. Crazy enough, the most fascinating find I have had was the first abandoned home I found and documented, and it is still my favorite place of all. I literally stumbled upon it, and it was near my own backyard with no driveway, no indication that anyone else had been inside of it or its outbuildings for years. It is amazing, and the information I have found makes it even more special. How can one not develop an abandoned addiction in this circumstance?

The man who lived here last had an extensive library of law books, World Almanacs, Encyclopedias, and antiques. The finds were amazing and historical. A former school superintendent, newspaper editor, attorney, and state representative, he made his space into a professional and historical haven. He died in 1936. Although the home has been lived in since then but not for a long time, it is evident that nobody had been in the barn for a very, very long time.

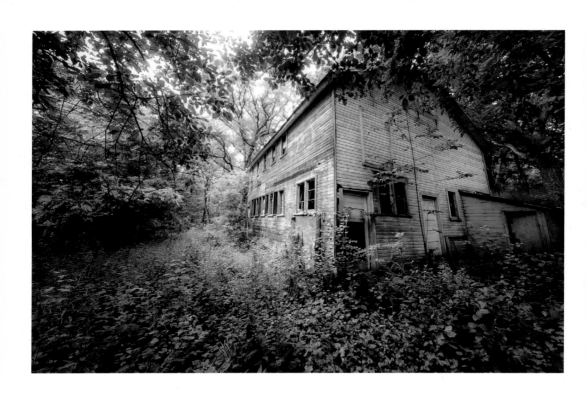

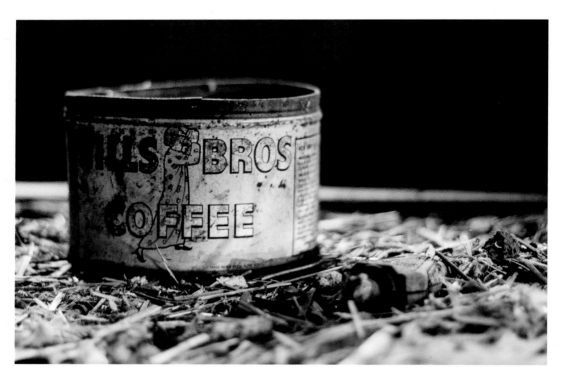

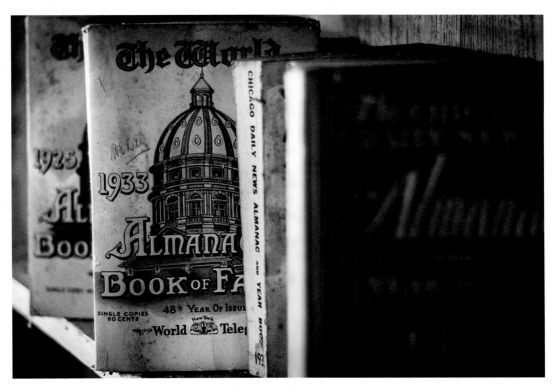

From the collection of World Almanacs; they spanned over twenty years

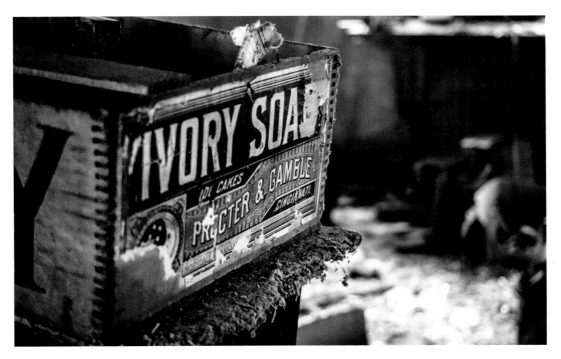

Antique Ivory Soap box

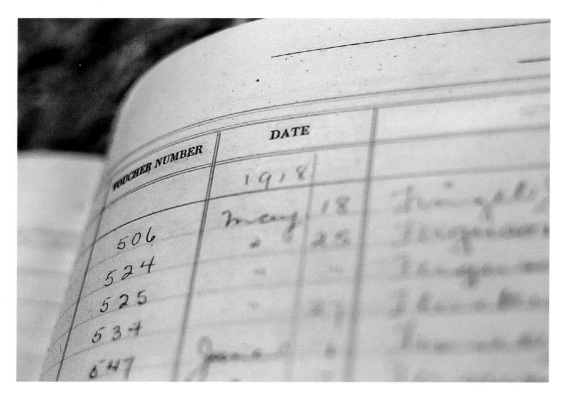

Register from 1917-1918

Slide out fabric storage container

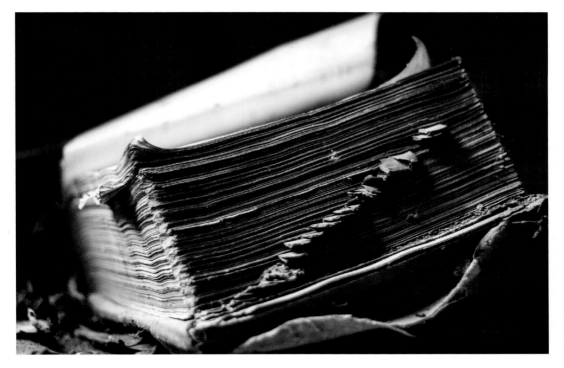

Rolodex from 1918

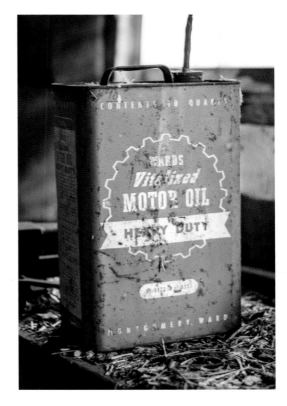

Petrified Motts

Window covering

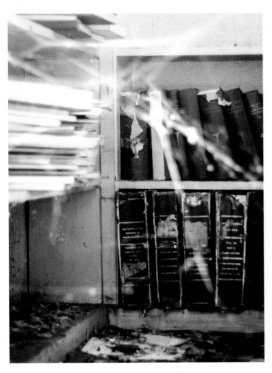

Spiderweb-covered books in the study

Broken bulb

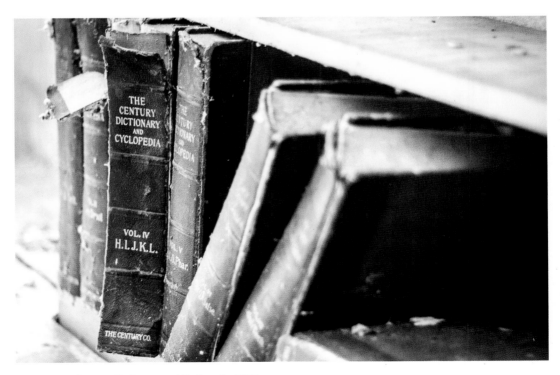

The Century Dictionary and Cyclopedia, 1900

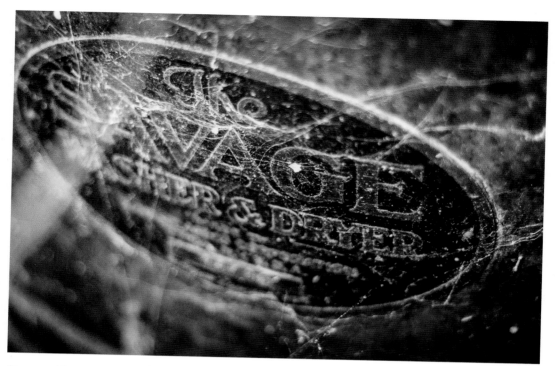

Close-up of the emblem for the Savage washer and dryer

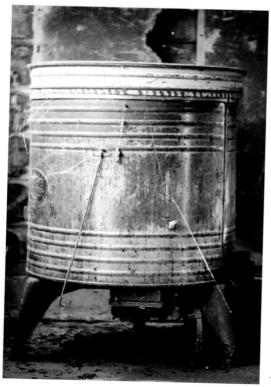

The Savage washer and dryer

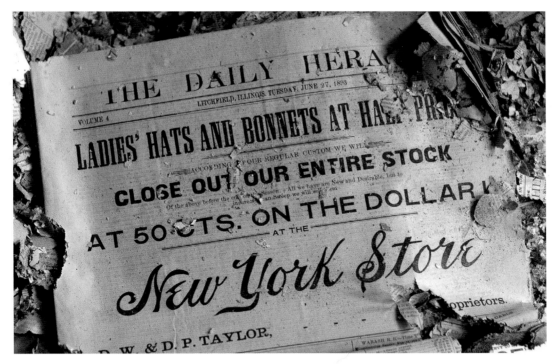

Newspaper from 1893; the owner of the home was the editor

Advertisement for "nervous prostration" from 1893 newspaper

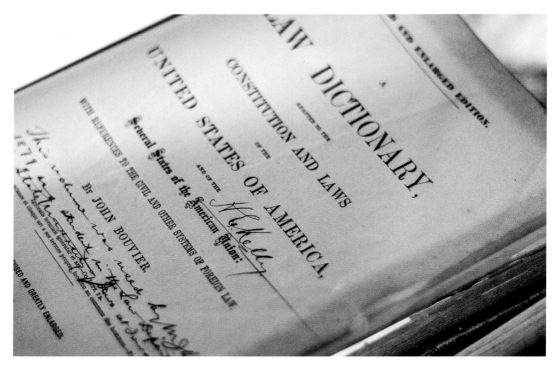

Law dictionary used when a member of the Colorado State House

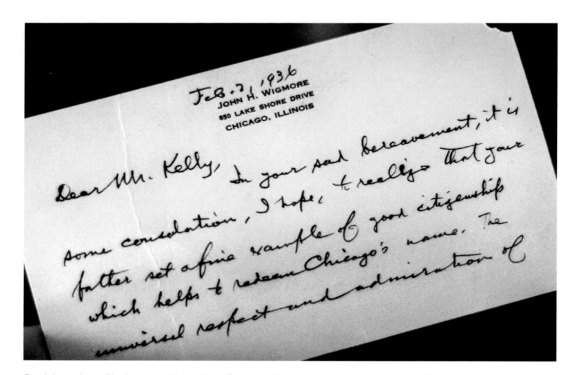

Feb. 7, 1936

JOHN H. WIGMORE
850 LAKE SHORE DRIVE
CHICAGO, ILLINOIS

Dear Mr. Kelly, In your sad bereavement, it is some consolation, I hope, to realize that your father set a fine example of good citizenship which helps to redeem Chicago's name. The universal respect and admiration of

Condolence letter. Northwestern University in Evanston, IL, has a law alumni club named after the author of this note, and he is the author of the famous and still used *Wigmore Papers*.

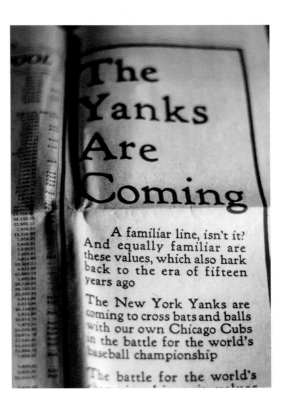

Article from the 1932 Yankees/Cubs World Series when Babe Ruth famously "called his shot out of the ballpark"

National Geographic magazines were chronologically stacked and tied together

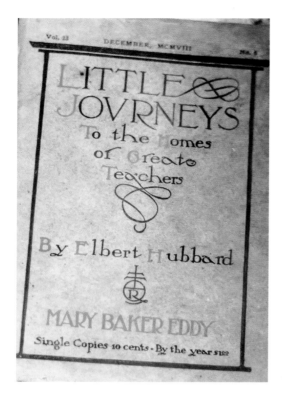

Many of the original "Little Journeys" pamphlets, by Elbert Hubbard, known to be influential in the Arts and Crafts movement and who died aboard the Lusitania in May of 1915, were found here

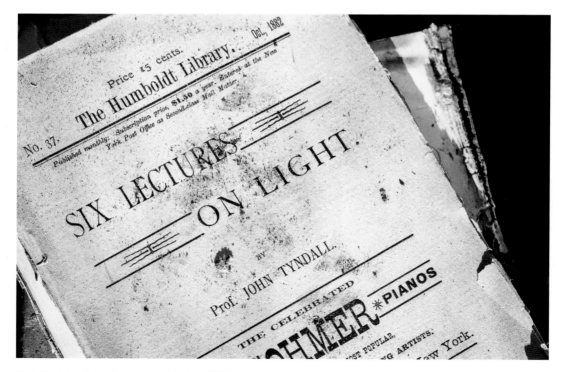

John Tyndall's Six Lectures on Light, *circa* 1882

Another house also looked to be completely untouched before me since the last person, an elderly widow, lived here, and she died in 1999. It was dusty and moldy, but amazing. A seamstress, hundreds of garments hang from makeshift clothes racks and dress patterns are spread throughout the rooms along with sewing supplies, letters, and family photographs.

Right: Recliner and blanket

Below: Vintage worm tablets

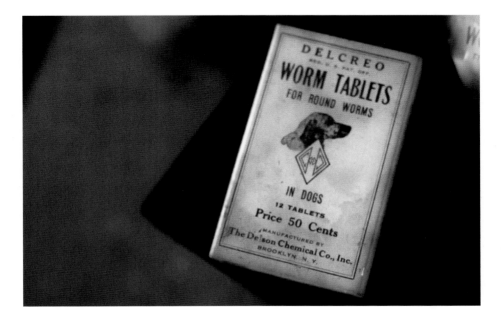

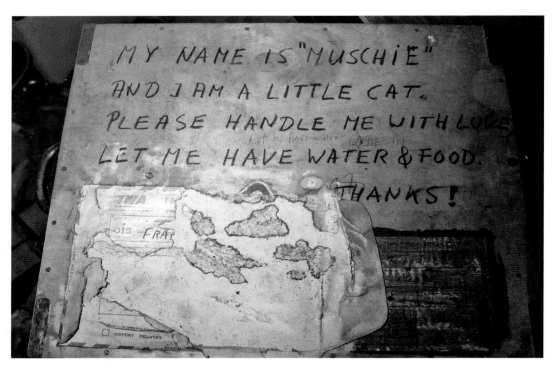

An aircraft crate for a kitten

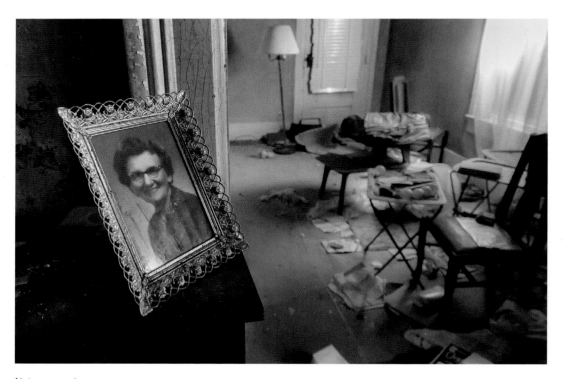

Not my grandma

There have been many other homes, too, and although probably not completely untouched, seemed to have been pretty much undisturbed. Out in the middle of nowhere and caving in, inhabited by a not-so-nice opossum and raccoon families, vintage toys, luggage, clothes, and records of lives can be found.

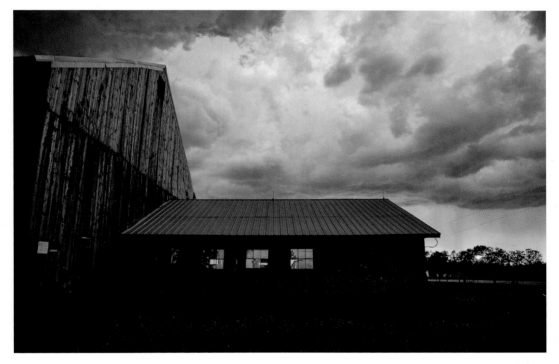

Abandoned barn; Northern Illinois

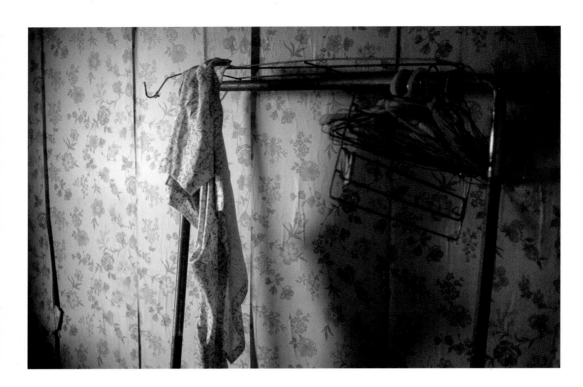

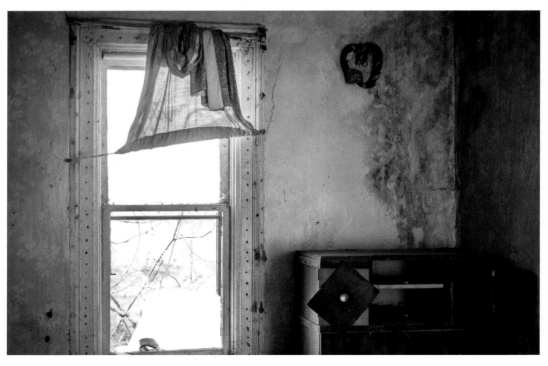

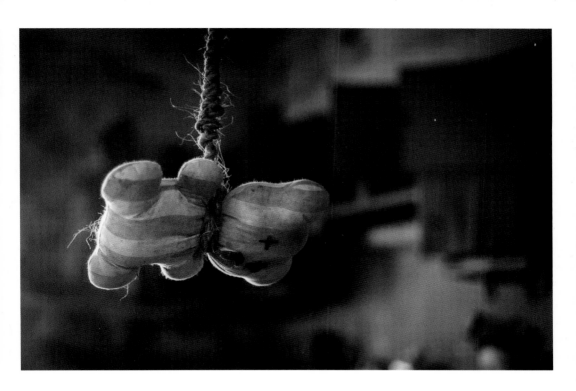

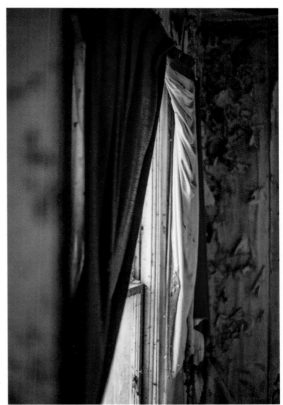

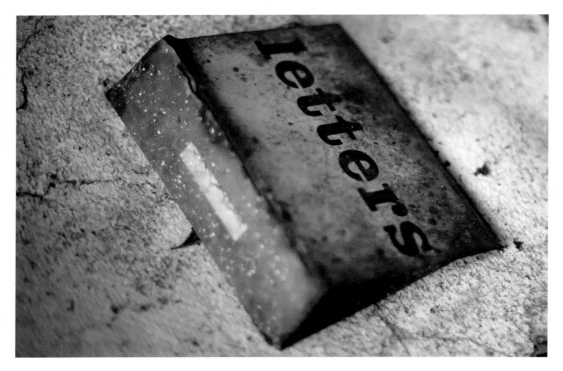

A binder full of letters

Peeling wallpaper is found in many abandoned homes

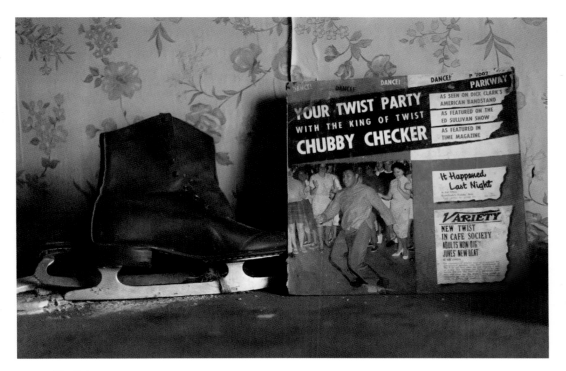

The Twist

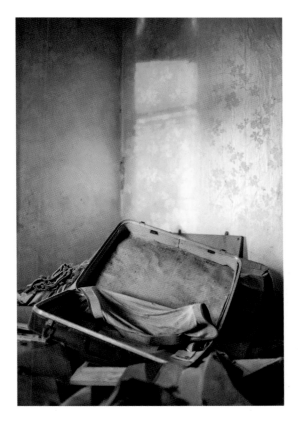

Unpacked

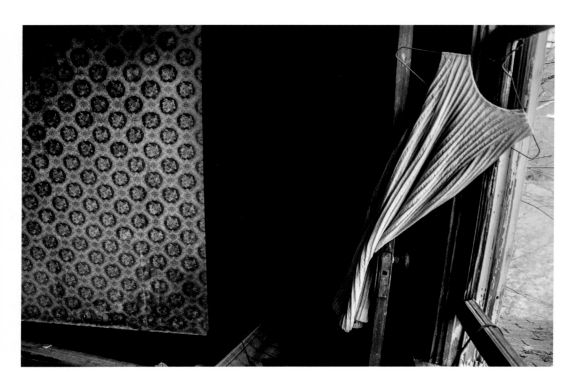

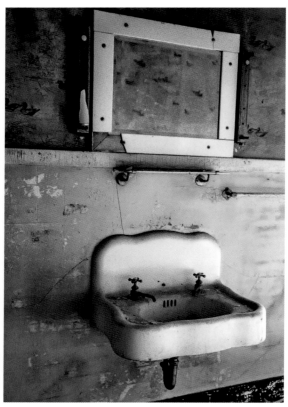

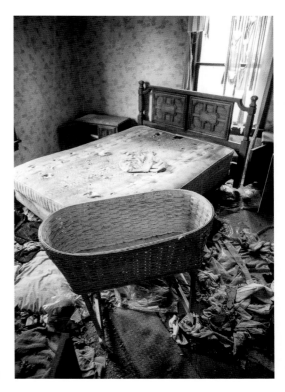

Vintage bassinet

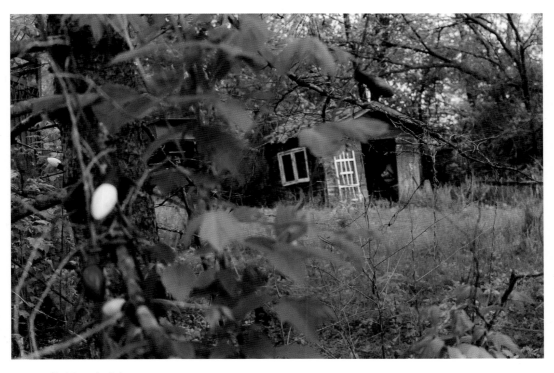

Christmas in July

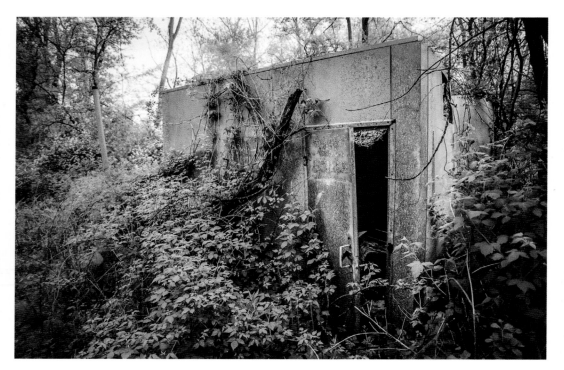

Bomb shelter

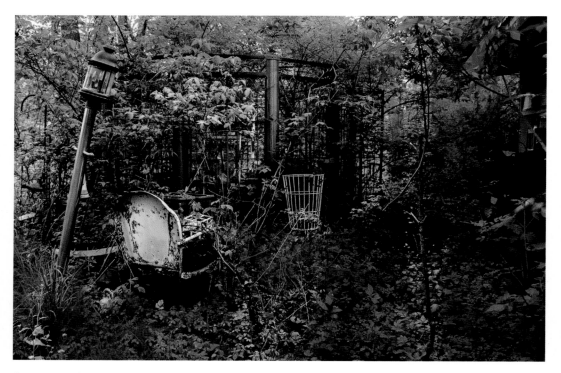

Overgrown patio

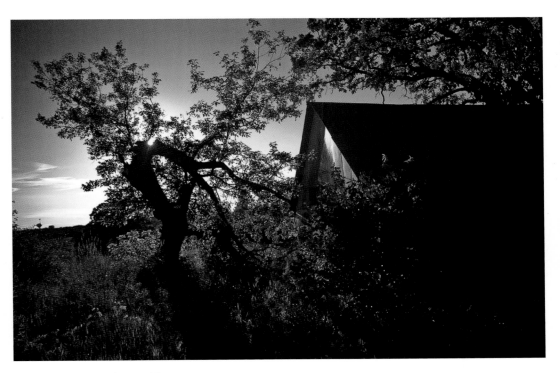

Overgrown abandoned barn

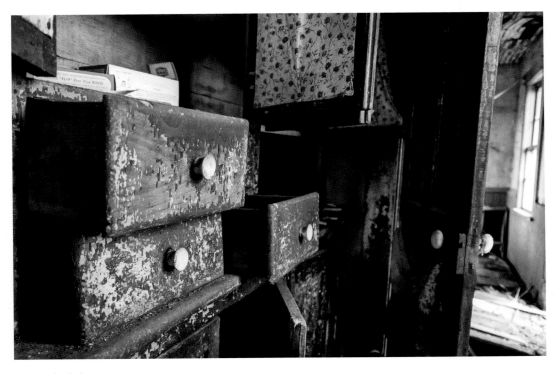

Junk drawers

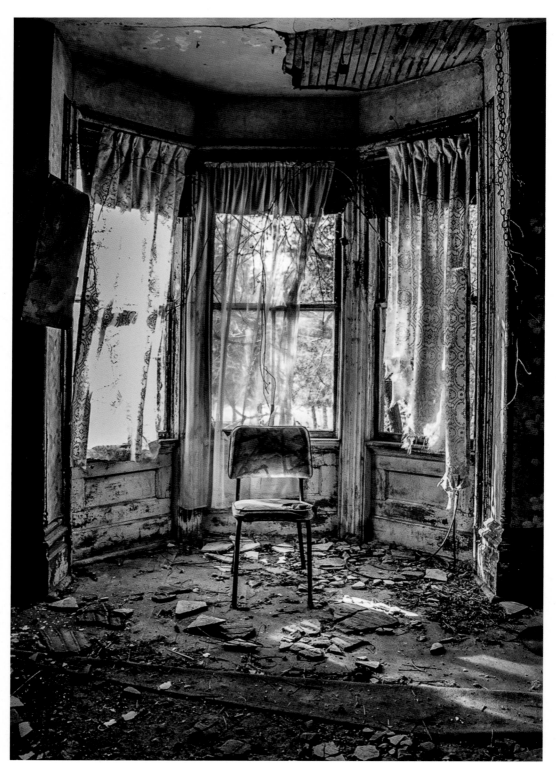

Ultralight beam

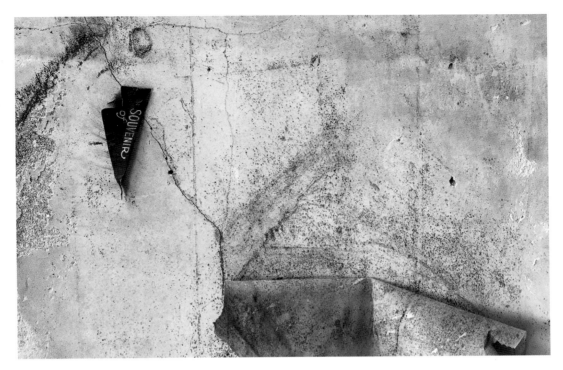

Souvenir flag

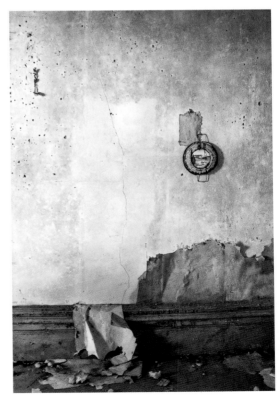

Stovepipe cover

Fly fisherman

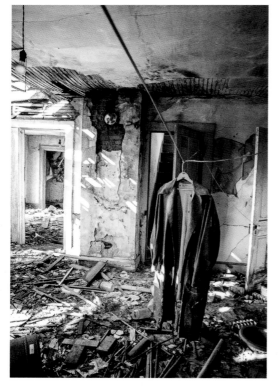

Trench coat

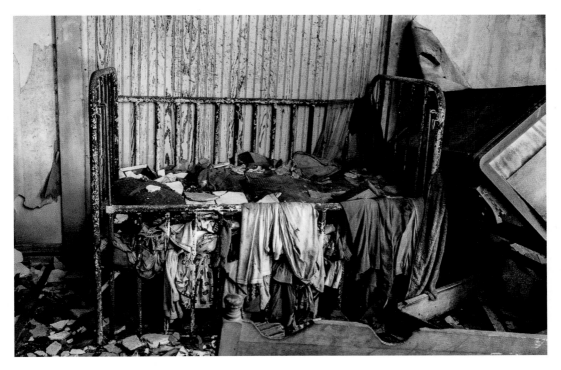

Crib

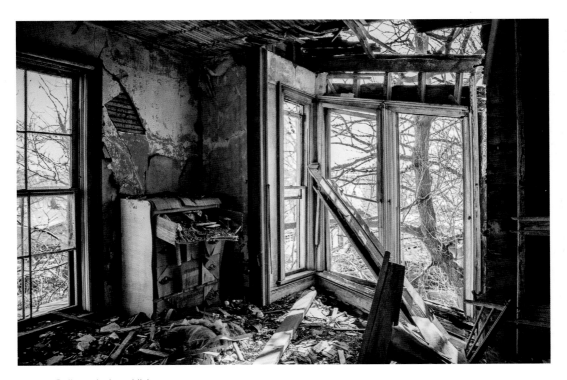

Roll top desk and living room

As documented in this book, there's nothing better to learn from than by stumbling upon a time warp. Whether a home, a factory, a school, a hospital, or a church, it is confounding to see how things are left behind; however, there is so much to be learned about ourselves, our history, and our culture through these places. To have been able to experience so many of them before they are gone forever has been nothing short of amazing.

ABOUT THE AUTHOR

LISA BEARD is a fine art photographer who also enjoys writing and creating mixed media art. She was born and continues to live in Woodstock, IL, a suburb of Chicago, where she is also a high school teacher and LRC director. Throughout life, Lisa has been drawn to exploration, especially the history behind abandoned spaces, and to photographing and documenting it. *Abandoned Illinois: Secrets Behind the Spaces* is her first published book. Volume II and Abandoned Wisconsin will soon follow. For more on Lisa and her work, please visit www.lisambeard.com.

[*Photo by Chehalis Hegner-Ganson*]

REFERENCES

Heinzmann, D. (2002, February 15). Prison in Joliet closing its doors after 144 years. *The Chicago Tribune*. Retrieved from http://articles.chicagotribune.com/2002-02-15/news/0202150063_1_stateville-correctional-center-maximum-security-prison-inmates

Ketchum, M. (1907). Grain elevator, Santa Fe system, Chicago. In *The design of walls, bins, and grain elevators* (Chapter xix). Retrieved from https://books.google.com/books?id=iawNAAAAYAAJ&pg=PA338&lpg=PA338&dq=santa+fe+grain+elevator+chicago&source=bl&ots=RLYWCFaFyD&sig=xWBiwTW6zTe3IWAj7HJfMc-CmA4o&hl=en&ei=7y0vTcjSM42asAPogM3uCQ&sa=X&oi=book_result&ct=result#v=onepage&q&f=false

Kumer, E. (2018, March 12). *The story of the silos, as told through explosions.* Retrieved from http://apps.northbynorthwestern.com/magazine/2018/winter/dancefloor/damen-silos/index.html

Lawson, R. (n.d.). *The Joliet Prison photographs, 1890-1930.* Retrieved from http://www.jolietprison.com/publications/catalog.asp

Marino, J. (2011, February 26). D.K. Products/Fox Valley Grease Factory history Huntley [web log comment]. Retrieved from https://cubfanbudman.wordpress.com/2011/02/26/d-k-products-fox-valley-grease-history/

National Mining Hall of Fame and Museum. (2018). *Inductee database: Goodman, Herbert.* Retrieved from https://www.mininghalloffame.org/inductee/goodman

Okon, B. (2018, March 22). City of Joliet changes its attitude about prison heritage: Prison town image gets new respect. *The Northwest Herald*. Retrieved from http://www.nwherald.com/2018/03/19/city-of-joliet-changes-its-attitude-about-prison-heritage/antk1vt/

Stanton, J. (2016, November 19). *Savanna Army Depot.* Retrieved from http://www.fortwiki.com/Savanna_Army_Depot

Sullivan, J. (2016, November 28). Inside an abandoned prison: Joliet Correctional Center [web log comment]. Retrieved from http://www.placesthatwere.com/2016/11/inside-joliet-correctional-center-abandoned-prison.html

U.S. Fish and Wildlife Service. (2016, June 3). *Lost Mound Unit: Upper Mississippi River National Wildlife and Fish Refuge environmental assessment.* Retrieved from https://www.fws.gov/Midwest/planning/LostMound/

U.S. Fish and Wildlife Service. (2012, January). *Lost Mound National Wildlife Refuge: Environmental assessment and interim comprehensive conservation plan.* Retrieved from https://www.fws.gov/Midwest/planning/LostMound/EA_november03.pdf

Wiedrich, B. (1990, January 2). Rail-car maker finds gold underground. *The Chicago Tribune.* Retrieved from http://articles.chicagotribune.com/1990-01-02/business/9001010237_1_locomotives-underground-mining-coal